PORTRAITS OF THE WORD

Illustrated in expressive calligraphy
with notes and prayers by the artist

Timothy R. Botts

Tyndale House Publishers, Inc.
WHEATON, ILLINOIS

Visit Tyndale's exciting Web site at www.tyndale.com

Copyright © 2001 by Timothy R. Botts. All rights reserved.

Cover art copyright © 2001 by Timothy R. Botts. All rights reserved.

Photograph copyright © 2001 by Brian MacDonald. All rights reserved.

Designed by Timothy R. Botts

Edited by Jeremy P. Taylor

Marbled paper on pages 45 and 125 by Charles and Gretchen Peterson

Published in association with the literary agency of Alive Communications, Inc., 1465 Kelly Johnson Blvd., Suite 320, Colorado Springs, CO 80920.

Library of Congress Cataloging-in-Publication Data

Botts, Timothy R.

Portraits of the word : illustrated in expressive calligraphy with notes and prayers by the artist / Timothy R. Botts.

 p. cm.

Includes bibliographical references and index.

ISBN 0-8423-5535-9

1. Bible—Meditations. 2. Bible—Illustrations. I. Title.

BS491.5 .B68 2001

242'.5—dc21

2001003673

Printed in China

06 05 04 03 02 01
6 5 4 3 2 1

This book is
dedicated with love to my wife

whose life perfectly complements mine.

IN GOD'S PLAN
MEN AND WOMEN
NEED EACH OTHER.

1 Corinthians 11:11
TLB

INTRODUCTION

For seventeen years I've been making word portraits from my meditations on the great texts of the Bible. This culminated with the publishing of a contemporary illumination of Scripture for the dawn of the new millennium. Some people have asked for my notes about the creative process, so I have chosen my favorite seventy-five pieces for inclusion in this volume. In addition to the notes, I've included prayers I have written in response to what God has taught me through each encounter with these holy words.

A new element on each devotional spread is my sketches, which preceded the finished works. These drawings serve to illustrate how the idea for each piece evolved from start to finish. Over and over again, making these pictures has rejuvenated my personal relationship with the Lord.

The sequence of the art begins with who God is and his revelation through Jesus Christ. Then it progresses from our response to our privileges and to our responsibilities. I hope that this visual expression of God's wondrous Word will be an experience of hope and celebration for you.

IN THE BEGINNING

GOD created the heaven; and the earth

Often artists start with a blank sheet of white paper. In this case I began with black to represent the darkness from which God began to paint. I've always had a special affinity, as an artist, for God's creative side. God loves uniqueness and diversity. Knowing this helps me to understand his great affection for us, because what artist doesn't love the product of his own work?

Creator God, we celebrate the incredible wonders of your works, remembering that we ourselves are a part of your genius. Help us to see your thumbprint all around us. Please bless the work of our own hands.

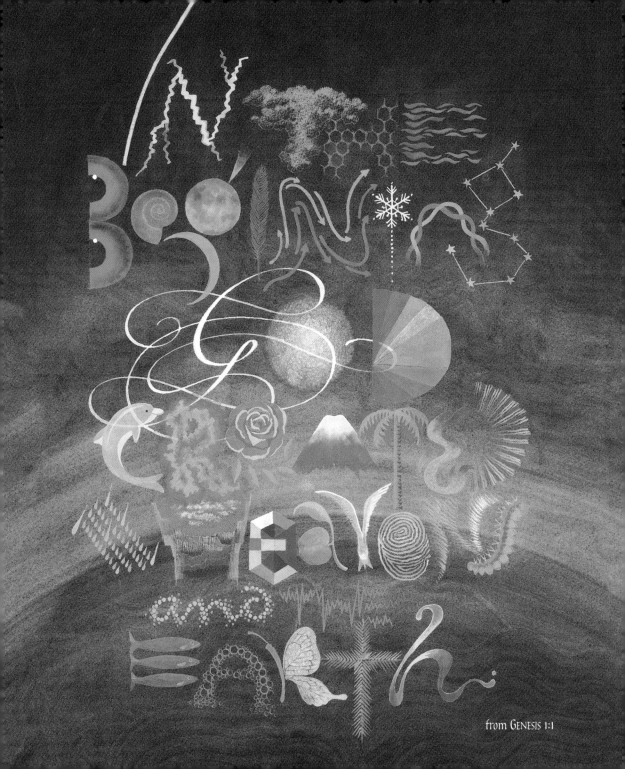

from GENESIS 1:1

I first did this piece in a predictable flaming red, but then I came upon this collage background I had made in a workshop. Since the flames did not consume the bush, it occurred to me that when God shows up growth occurs—symbolized by the color green. It is a reminder to me of the importance of thinking oppositely in the creative process.

⸭

Jehovah, God of all time, even as you mightily used Moses to speak before Pharaoh, we offer ourselves to your service. Thank you that our little can become much in your hands.

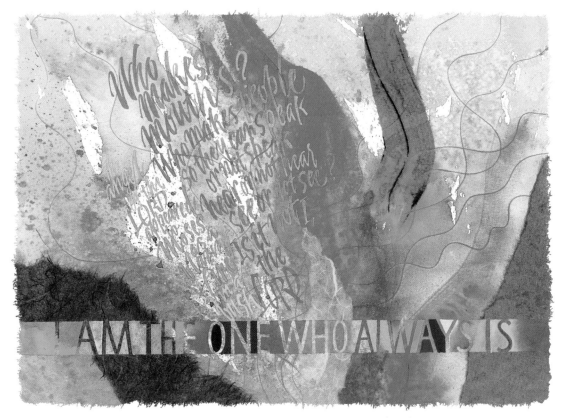

Who makes mouths? Who makes people so they can speak or not speak, or can hear or not hear, or can see or not see? Is it not I, the LORD?

I AM THE ONE WHO ALWAYS IS

from EXODUS 3:2, 14; 4:11

I used contrasting pictures here to illustrate the place of Scripture in our lives. The flowing blue background represents the Greek derivation of inspiration as God-breathed and alludes to the Word's ability to purify us. The straight lines of the compass point to the clear direction God gives us.

Word of God, how we thank you for communicating and preserving your message for us! Help us to submit to your teachings so that we may become the people you want us to be.

AND IS USEFUL
TO TEACH US
WHAT IS TRUE
AND TO MAKE US REALIZE
WHAT IS WRONG IN OUR LIVES
IT STRAIGHTENS US OUT
AND TEACHES US TO DO
WHAT IS RIGHT

ALL SCRIPTURE IS INSPIRED BY GOD

and is useful to teach us what is true and to

make us realize what is wrong in our lives

It straightens us out and teaches us

to do what is right

from 2 TIMOTHY 3:16

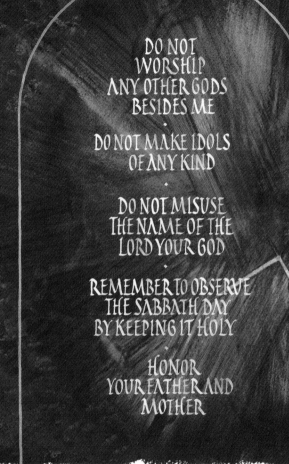

DO NOT
WORSHIP
ANY OTHER GODS
BESIDES ME
·
DO NOT MAKE IDOLS
OF ANY KIND
·
DO NOT MISUSE
THE NAME OF THE
LORD YOUR GOD
·
REMEMBER TO OBSERVE
THE SABBATH DAY
BY KEEPING IT HOLY
·
HONOR
YOUR FATHER AND
MOTHER

When I read the dramatic way that God delivered the Ten Commandments to his people, it brings back childhood memories of watching this scene on the big screen in the Cecil B. DeMille film. Although the Judeo-Christian tradition is sometimes

DO NOT
MURDER

·

DO NOT
COMMIT ADULTERY

·

DO NOT
STEAL

·

DO NOT
TESTIFY FALSELY
AGAINST
YOUR NEIGHBOR

·

DO NOT
COVET ANYTHING
YOUR NEIGHBOR
OWNS

from EXODUS 20:3-17

viewed negatively for its prohibitions, we can see that the troubles of our society stem from our abandonment of these foundational laws.

Most Holy God, we tremble at your demands and realize that we fall short of such perfection. Thank you for your grace offered through Jesus Christ and for the power of your Spirit to help us do what we can't do alone.

…ra read aloud the Book of the Law…
…ple had been weeping as they listened…
…EHEMIAH CONTINUED…
…it be dejected and sad for…
the joy of the Lord is your strength

So the people went away with great joy because they had heard God's words and understood them

For those of us who live in affluent countries with a Christian heritage, it is all too easy to take the presence of Bibles for granted. But in places like China, where Bibles are rare, the response to God's words is the same as in Nehemiah's day. I followed a basic principle of design by choosing the heart of the longer text and emphasizing it in color.

·:·

God, our source of joy, forgive us when we have looked for satisfaction in other places. Replace our weakness with the surety of your good purposes for us.

8

From early morning
until noon Ezra read aloud
the Book of the Law.
All the people had been
weeping as they listened.
And Nehemiah continued,
Don't be dejected and sad
for

The joy
of the Lord
is your
Strength

So the people went away
with great joy because
they had heard God's words
and understood them.

from NEHEMIAH 8:3, 9-10, 12

Jim Stambaugh, director of the Billy Graham Center Museum, once reminded me that visual art is its own language, which, like all languages, must be learned. The background of this piece speaks of the birth canal, the drama of one's passage through life, a veiled future, and dark unknowns along the way. As a calligrapher, my challenge is to add the words harmoniously to what is already put down.

Lord of our times, help us to appreciate the gift of each day, to be alive to your world. Help us to make the most of the time you give us and to hold lightly the things you have loaned to us. Please don't allow us to trust in our possessions. Instead, may we learn to rest solely in your wisdom and character.

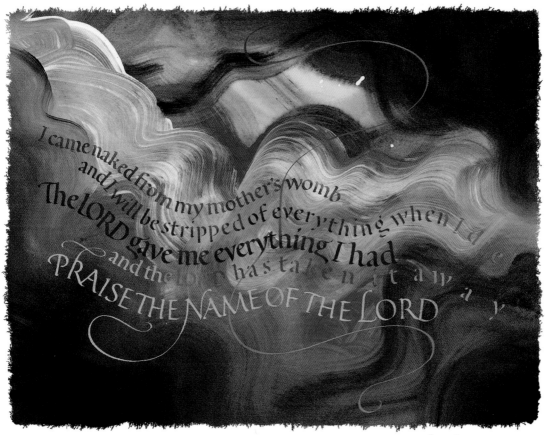

I came naked from my mother's womb
and I will be stripped of everything when I d
The LORD gave me everything I had
and the LORD has taken it away
PRAISE THE NAME OF THE LORD

from JOB 1:21

God's reply to Job's complaining came out of a whirlwind and provided a dynamic visual setting for me in which to place the text. Three millennia later God's words continue to challenge our culture's arrogance. Laying out these various questions about the created order all together confirmed for me the exquisite drama of it all.

∴∴∴

God of mystery and might, we confess our inability to understand or control the world around us. Give us eyes to see your glorious design behind it all. Give us wisdom to use our limited knowledge in harmony with your perfect will.

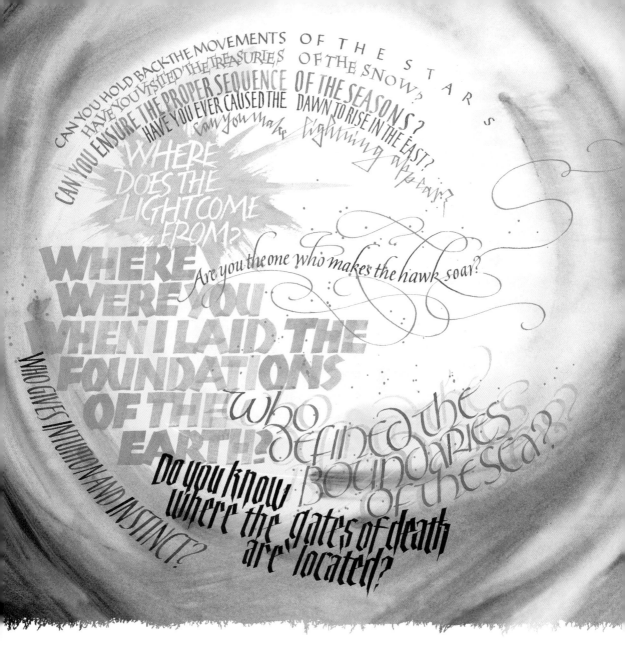

CAN YOU HOLD BACK THE MOVEMENTS OF THE STARS?
HAVE YOU VISITED THE TREASURIES OF THE SNOW?
CAN YOU ENSURE THE PROPER SEQUENCE OF THE SEASONS?
HAVE YOU EVER CAUSED THE DAWN TO RISE IN THE EAST?
Can you make lightning appear?

WHERE DOES THE LIGHT COME FROM?

Are you the one who makes the hawk soar?

WHERE WERE YOU WHEN I LAID THE FOUNDATIONS OF THE EARTH?

WHO GIVES INTUITION AND INSTINCT?

Who defined the boundaries of the sea?

Do you know where the gates of death are located?

from JOB 38:4-36; 39:26

The sailboat is drawn as a traditional blueprint with many of the lines converging to a single focal point. The colors within the circle reveal the rich plan that is being mapped out behind the scenes. As I look back, my experience has been that in trusting God to lead me, my life has been better than I could have ever planned myself.

Lord of life, please take over the helm and guide us through the inevitable storms. Thank you for bringing us this far and for the final destination of being in your awesome presence.

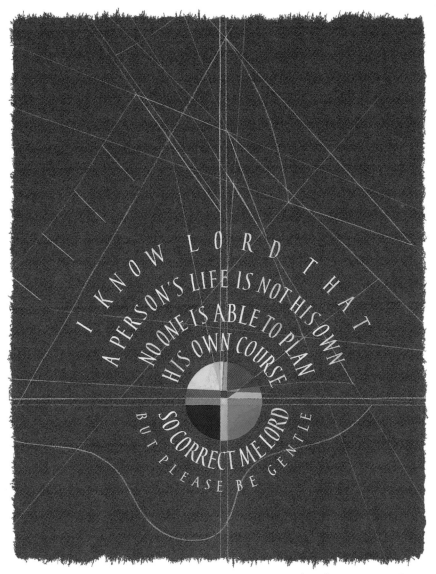

I KNOW LORD THAT
A PERSON'S LIFE IS NOT HIS OWN
NO ONE IS ABLE TO PLAN
HIS OWN COURSE
SO CORRECT ME LORD
BUT PLEASE BE GENTLE

from JEREMIAH 10:23-24

Teach these commandments
to your children
and talk about them
when you are at home
or out for a walk;
at bedtime
and the first thing
in the morning.

Tie them on your finger;
wear them on your forehead
and write them
on the doorposts
your house.

These verses have been my prime motivation for reproducing Scripture artistically so that God's words can always be before our eyes. The inner arch of multicolored words was the inspiration for my first book, *Doorposts*. It reminds us of our responsibility to teach our children well.

⋮∴⋮

Lord of all generations, thank you for those who faithfully taught us about you. Help us to demonstrate our love for you by our own teaching and example for those coming after us.

COMMIT YOURSELVES WHOLEHEARTEDLY TO THESE COMMANDS I AM GIVING YOU TODAY

Repeat them again and again to your children. Talk about them when you are at home and when you are away on a journey, when you are lying down and when you are getting up again. Tie them to your hands as a reminder, and wear them on your forehead. Write them on the doorposts of your house and on your gates.

Love the Lord your God with all your heart all your soul and all your strength

from Deuteronomy 6:5-9

A living rock is quite a paradox. I chose a solid style of lettering to convey the stability I have experienced by depending on the Lord. The changing colors and the delicate flourishes represent God's activity among us as well as our praise offered to him.

Our Lord and Savior, we celebrate with David your almighty strength. Thank you that, as we trust in you, you deliver us from all that would destroy us. Hallelujah!

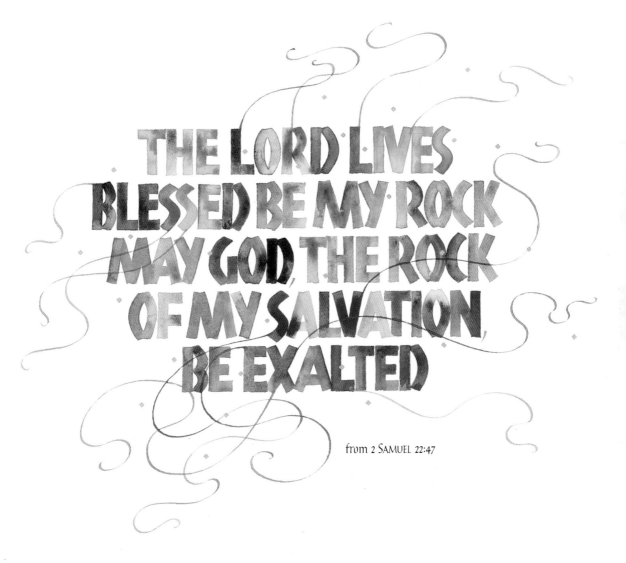

THE LORD LIVES
BLESSED BE MY ROCK
MAY GOD, THE ROCK
OF MY SALVATION,
BE EXALTED

from 2 SAMUEL 22:47

THE
WORD
became human
and lived here
on earth
among us.

He was
full of unfailing
love and
faithfulness
A N D
WE HAVE SEEN
HIS GLORY
THE GLORY OF
THE ONLY SON
OF THE FATHER

The beginning of the Gospel of John parallels Genesis with the amazing creative act of God's own entrance into human history. The imagery in John 1 is evidence that visual art is a valid expression for us to use in our communication back to God. The swirling background here represents the unfolding of God's remarkable plan; the descending figure is Jesus, stooping to become one of us.

Glorious Lord, we are awed by your choice to become one of us. Thank you for affirming our humanity and for showing us how we should live. May we reflect your glory where it is needed.

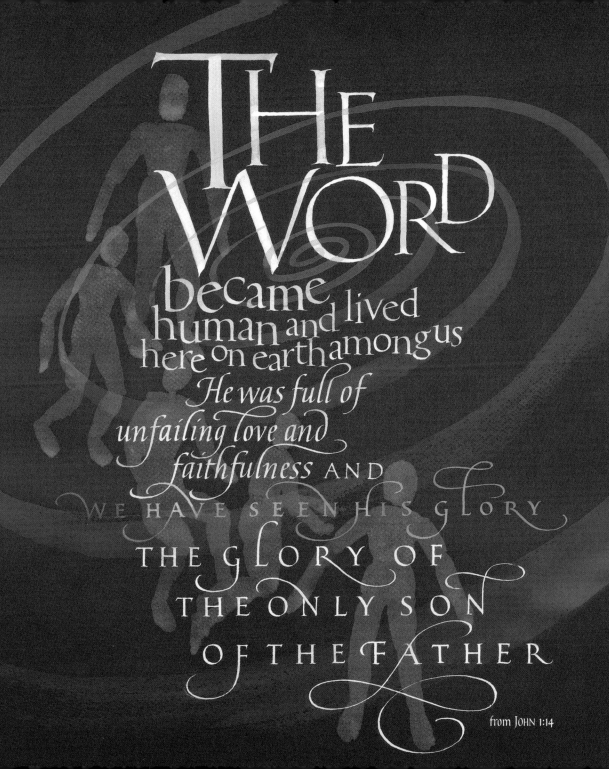

THE WORD became human and lived here on earth among us He was full of unfailing love and faithfulness AND WE HAVE SEEN HIS GLORY THE GLORY OF THE ONLY SON OF THE FATHER

from JOHN 1:14

When I begin the design of a text, I often make a word picture of each phrase. Then I simplify the composition by choosing the style that represents the strongest theme of the whole. But in this famous verse, I found each word or phrase to be so significant that I retained its visual complexity. God's name, which is always the greatest challenge to write, is done in radiating dots of color. It illustrates him as the source of the great plan for our salvation.

God and Savior, thank you for making a way for us to experience life beyond the grave. Thank you for including every one of us who comes to you!

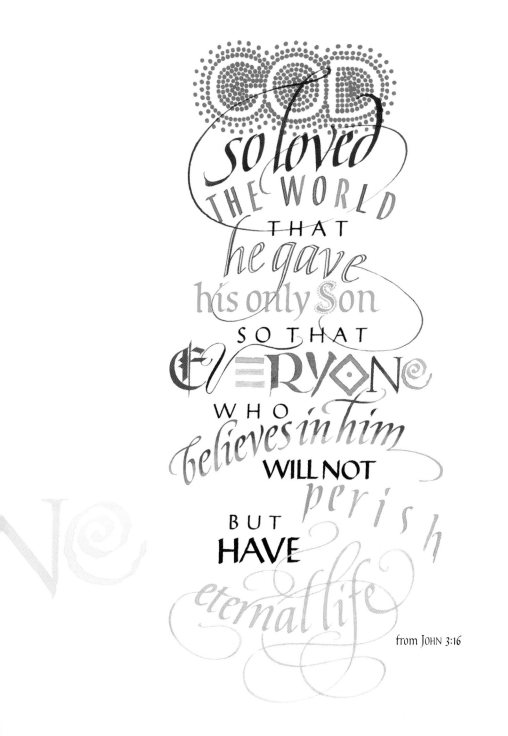

GOD
so loved
THE WORLD
THAT
he gave
his only Son
SO THAT
EVERYONE
WHO
believes in him
WILL NOT
perish
BUT
HAVE
eternal life

from JOHN 3:16

JESUS STOOD UP
AND REBUKED THE
WIND AND WAVES
AND SUDDENLY
ALL WAS CALM
THE DISCIPLES JUST
SAT THERE IN AWE
WHO IS THIS?
THEY ASKED THEMSELVES
EVEN THE WIND
AND WAVES
OBEY HIM!

I wanted to create here a picture of stability in the midst of great turbulence. So I started with a background that shows a combination of overwhelming wind and waves. The remarkable account of Jesus' taming of the storm is written in the strongest style of capitals I could manufacture. The size of the boat compared to the storm underscores our helplessness in the face of such chaos apart from God.

God of might and miracles, thank you for this record of your power. We trust you to bring us through the storms with which we are currently struggling.

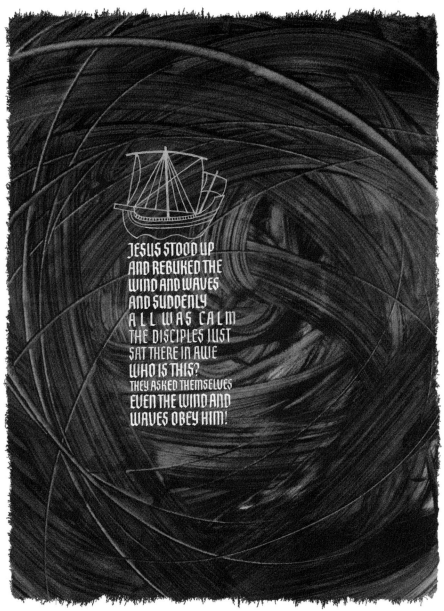

JESUS STOOD UP
AND REBUKED THE
WIND AND WAVES
AND SUDDENLY
A L L W A S C A L M
THE DISCIPLES JUST
SAT THERE IN AWE
WHO IS THIS?
THEY ASKED THEMSELVES
EVEN THE WIND AND
WAVES OBEY HIM!

from MATTHEW 8:26-27

The Spirit of the Lord is upon me for he has appointed me to preach good news to the poor. He has sent me to proclaim that captives will be released, that the blind will see, and that the time of the Lord's favor has come.

There is a feeling of power in taking a large sheet of paper and covering it with just a few large words. In a similar way, Jesus was wonderfully and mysteriously filled with God's Spirit to accomplish his unique works on earth. I chose to highlight the four types of people Jesus reached out to: the poor, the captives, the blind, and the downtrodden.

Spirit of God, thank you for filling us with all good things. Thank you for newfound freedoms, for revealing our blind spots, and for giving us a noble position as your children.

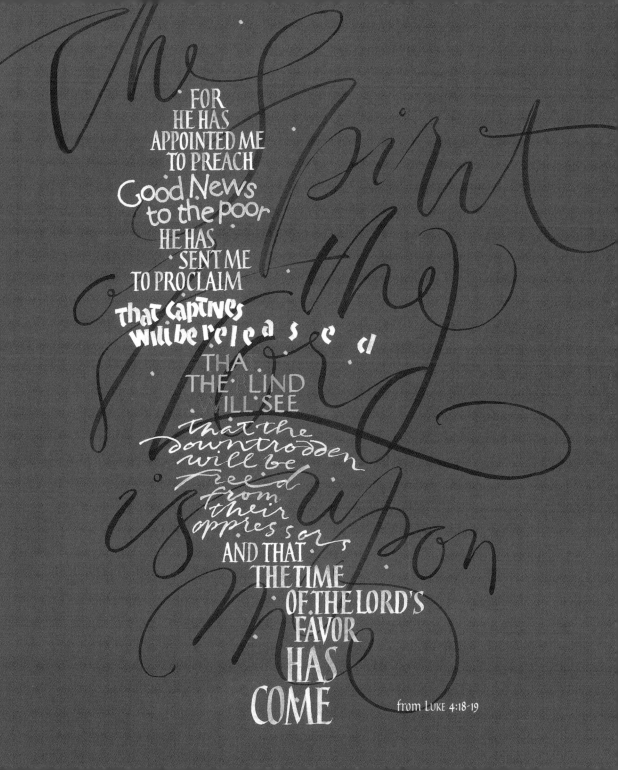

The Spirit of the Lord is upon Me

FOR
HE HAS
APPOINTED ME
TO PREACH
Good News
to the poor
HE HAS
SENT ME
TO PROCLAIM
That Captives
will be released
THAT
THE BLIND
WILL SEE
that the
downtrodden
will be
freed
from
their
oppressors
AND THAT
THE TIME
OF THE LORD'S
FAVOR
HAS
COME

from LUKE 4:18-19

JESUS REPLIED

I AM
THE BREAD
OF LIFE
NO ONE WHO COMES TO ME
WILL EVER BE HUNGRY AGAIN
THOSE WHO BELIEVE IN ME
WILL NEVER THIRST

I started this piece with the choice of handmade paper containing natural fibers. Like these bits and pieces, Jesus is, at the most basic level, everything our soul needs to be complete. Then I tried to make the most universal, recognizable shape for bread in stencil form to emphasize the spiritual dimension of Jesus' claim.

Living Bread, thank you for being the source of true satisfaction. Thank you for the good gifts all around us, for the gift of your own splendor shared with us, for the perfect way you have laid out for us. Keep us from empty pursuits.

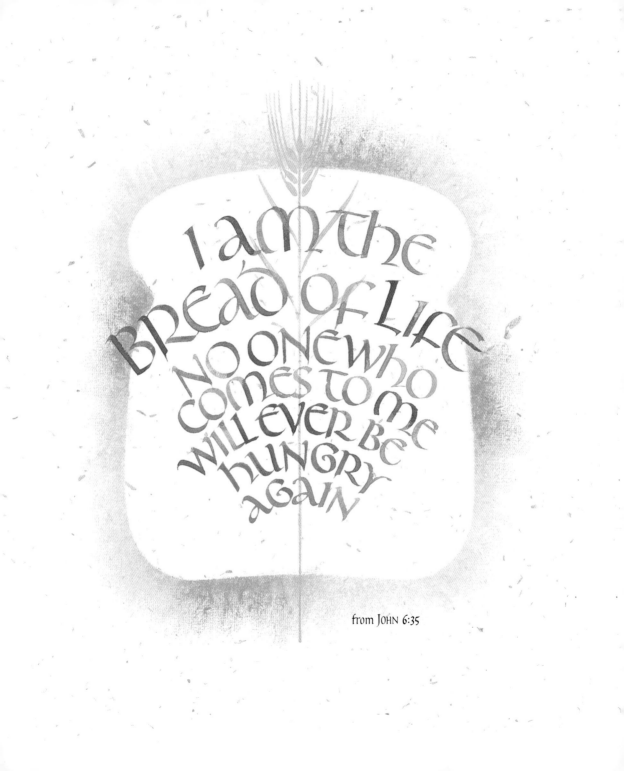

I AM THE
BREAD OF LIFE
NO ONE WHO
COMES TO ME
WILL EVER BE
HUNGRY
AGAIN

from JOHN 6:35

I AM THE VINE you are the branches Those who remain in Me and I in them will produce much fruit

This verse gives us a beautiful picture of a life lived in union with Christ. But it is followed with a sober warning that a life without him is futile. To picture this, the brightest part of the art is "the vine," while the weakest part, the warning, is shown drifting away.

Mighty God, help us to stay as close to you as we can. Thank you for the harvest you have promised as we remain connected with you.

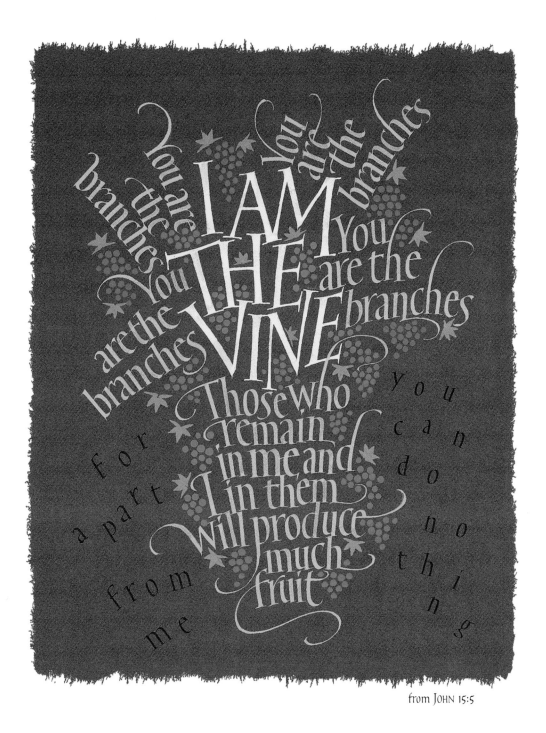

You are the branches
You are the branches
You are the branches
I AM THE VINE
You are the branches
branches
Those who remain in me and I in them will produce much fruit
for apart from me you can do nothing

from JOHN 15:5

I AM
THE RESURRECTION
AND
The Life
Those who believe in me
EVEN THOUGH
they die like everyone else
will live again
from

The whole drama of caterpillar to cocoon to butterfly pictures for us the same hope we have for heavenly bodies. But because the verse is about resurrection and not butterflies, I painted it more as a symbol of what we cannot yet see.

Risen Lord, we rejoice in your unique promise of eternal life and in your demonstration of power that overcomes the grave. Free us from our own fear of death to live in resurrection hope.

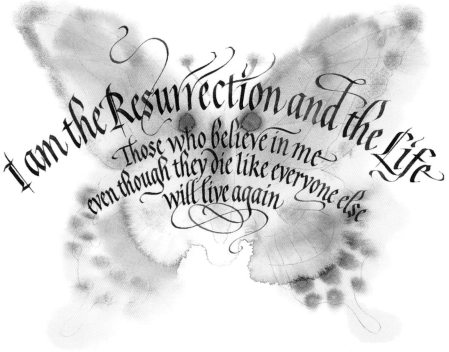

I am the Resurrection and the Life

Those who believe in me
even though they die like everyone else
will live again

from JOHN 11:25

The overall emotion of this Gospel account is represented by flowing, downward movement. Harold Best, former dean of the Wheaton Conservatory of Music, said that artists who love Jesus should make their art like the offering of the woman in this story—lavishly poured out in praise of Christ.

. . .
. . .
.

Wonderful Savior, in response to your forgiveness, we offer the best gifts that we can give. We are encouraged that in spite of our crookedness, you receive our sincere offerings of thankfulness. We love you because you first loved us.

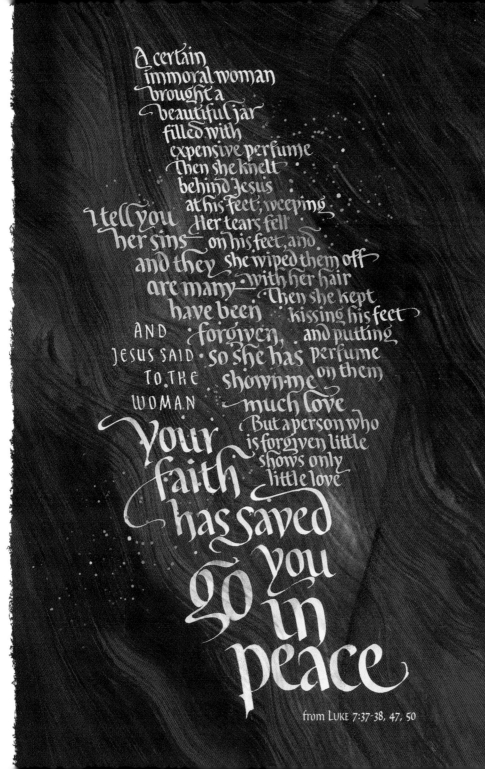

A certain immoral woman brought a beautiful jar filled with expensive perfume. Then she knelt behind Jesus at his feet, weeping. Her tears fell on his feet, and she wiped them off with her hair. Then she kept kissing his feet and putting perfume on them.

I tell you, her sins—and they are many—have been forgiven, AND JESUS SAID TO THE WOMAN so she has shown me much love. But a person who is forgiven little shows only little love.

Your faith has saved you go in peace

from LUKE 7:37-38, 47, 50

The Son of Man came here not to be served but to serve others and to give my life

Writing out a statement of vision or purpose has become an important exercise for many businesses and organizations. It occurred to me that this verse was Jesus' mission statement, which he realized perfectly on our behalf. From a foreshadowing of the Cross, Christ's words flow freely and purposefully.

Lord Jesus, thank you for the amazing grace of your great earthly mission. Thank you for paying the penalty for our sin so that we can become part of your kingdom. Help us to be people who freely serve each other.

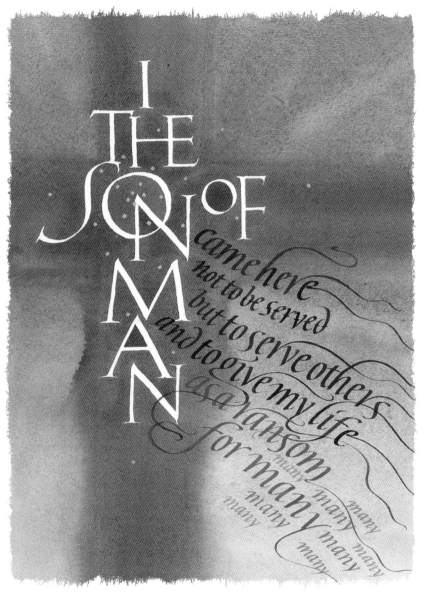

I THE SON OF MAN came here not to be served but to serve others and to give my life as a ransom for many many many many many many

from MATTHEW 20:28

How amazing that these words about the Messiah were written seven hundred years before the birth of Jesus! The circle shows up a lot in my biblical work as an eternal symbol, representing the text's universal application. In this case it also alludes to the crown of thorns that Jesus wore.

Redeemer Lord, thank you for identifying with our suffering and for making a way of escape from the downward spiral of sin. Help us to remember what it cost for you to reconcile us with your holy nature.

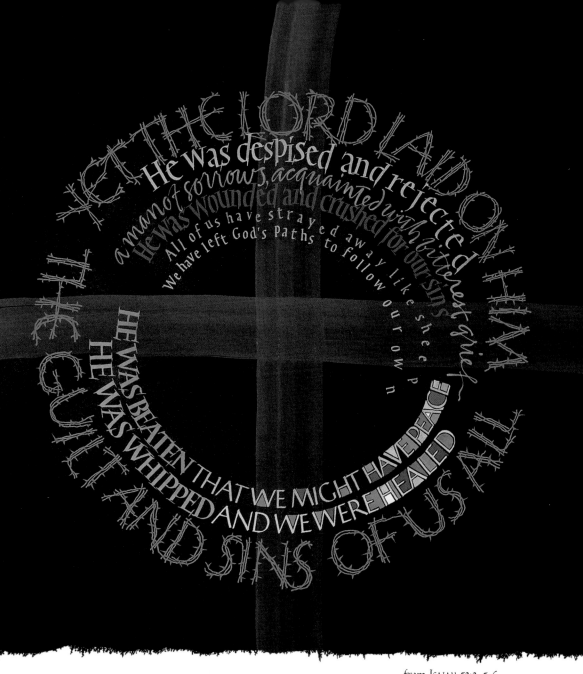

YET THE LORD LAID ON HIM

HE

THE GUILT AND SINS OF US ALL

He was despised and rejected
a man of sorrows, acquainted with bitterest grief—
He was wounded and crushed for our sins
All of us have strayed away like sheep
We have left God's paths to follow our own

HE WAS BEATEN THAT WE MIGHT HAVE PEACE
HE WAS WHIPPED AND WE WERE HEALED

from ISAIAH 53:3, 5-6

Can you see in my work the influence of living in Japan for three years? The inner shape represents our sin; the surrounding red the remedy, the shed blood of Christ. This is the simple but elegant plan of the eternal God as expressed by a perfect gold circle. The white letters signify God's declaration that in this one act we are made pure—as though we never sinned!

Our Savior and our God, we marvel at your singular plan to get rid of our sin. Thank you for finding a way that satisfied both your justice and your love so that we can be reinstated into your family.

God made Christ
who never sinned
to be the offering
for our sin, so that
we could be made
right with God
through Christ

from 2 CORINTHIANS 5:21

I KNOW THAT
my Redeemer lives
AND THAT
HE WILL STAND UPON THE EARTH AT LAST
and after my body has decayed
YET IN MY BODY
I WILL SEE
GOD

I am a timid illustrator who is better at writing letters than drawing pictures. But here it was appropriate to hide the image of a person in the background. It represents Job's amazing statement of faith that someday God will give us new bodies.

• • •
• • •
• • •

Risen Lord, how wonderful that in our physical ailments and limitations of the present, we can look forward to a new body. We rejoice in your victory over death and in your promise that one day we will have eyes that can see you more perfectly.

I
KNOW
THAT
MY
REDEEMER
lIVES
AND THAT
HE WILL STAND
ON THE EARTH
AT LAST
AND AFTER MY BODY
HAS DECAYED
YET
IN MY BODY
I WILL
SEE
GOD

from JOB 19:25-26

BECAUSE OF THIS
GOD RAISED HIM UP
TO THE HEIGHTS OF
HEAVEN AND GAVE
HIM A NAME THAT IS
ABOVE EVERY OTHER
NAME, SO THAT AT
THE NAME OF

Jesus

EVERY KNEE WILL
BOW, IN HEAVEN
AND ON EARTH AND
UNDER THE EARTH
AND EVERY TONGUE
WILL CONFESS THAT
JESUS CHRIST IS
LORD TO THE GLORY
OF GOD THE FATHER

My friend Chuck Peterson's experimental marbled paper provided the heavenly contrast with the torn paper of earth's trials. Jesus' name reaches from the very top of the composition to the very bottom, representing the ultimate move from glory to humiliation and back to glory again.

Lord Jesus, how amazing for you to condescend to the likes of us in order that we may share in your heavenly home! We offer you our deepest thanks and allegiance, for you are most worthy.

BECAUSE OF THIS
GOD RAISED HIM UP
TO THE HEIGHTS OF HEAVEN
AND GAVE HIM A NAME THAT IS
ABOVE EVERY OTHER NAME
SO THAT AT THE NAME OF

JESUS

EVERY KNEE
WILL BOW IN
HEAVEN AND
ON EARTH AND
UNDER THE EARTH
AND EVERY TONGUE
WILL CONFESS THAT
JESUS CHRIST IS LORD
TO THE GLORY OF
GOD THE FATHER.

Your attitude
should be the same
that Christ Jesus had.
Though he was God,
he did not demand
and cling to his rights
as God.
He made himself
nothing;
he took the
humble
position
of a slave and
appeared in
human form...
he obediently
humbled himself
even further
by dying a
criminal's death
on a cross.

from PHILIPPIANS 2:5-11

In the process of designing elements on a page, it's a great sensation to discover an arrangement that pictures the message perfectly! That happened when I found that one footprint could fit exactly inside the hollow of a larger one. This image represents the truth that Jesus walks with us through life but also surrounds us, protecting us and guiding us in all we do. The torn paper images are symbolic so that they could be my feet or yours.

·
· · ·
· · · · ·
· · ·
·

Lord Jesus, thank you for the great sacrifice you made for us to be forgiven and adopted as your children. Thank you that as we follow your perfect way, you not only go ahead of us but surround us with your care.

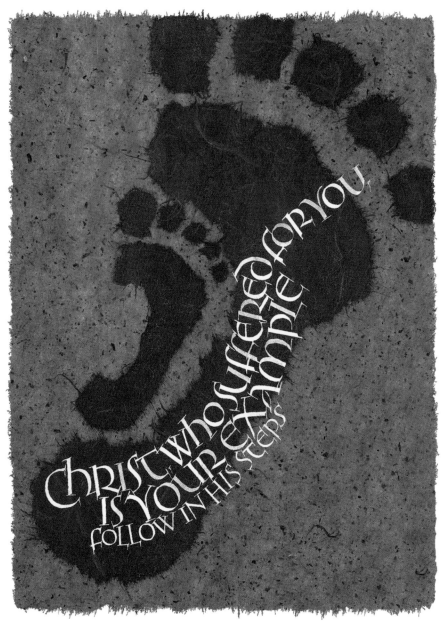

Christ, who suffered for you, is your example. Follow in his steps.

from 1 PETER 2:21

Each day is a gift. The word *today* has great significance for me because the relevancy of the Bible's message influences my work as an artist. Although many of the styles I use come from the medieval period, I am always trying to represent the words in the visual vocabulary of our time.

Lord of life, thank you for all the possibilities you have for us. Help us to make good choices so that we will not miss out on the best that you have in store for us.

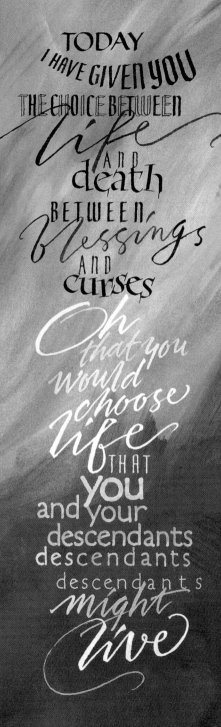

TODAY
I HAVE GIVEN YOU
THE CHOICE BETWEEN
life
AND
death
BETWEEN
blessings
AND
curses
*Oh
that you
would
choose
life*
THAT
you
and your
descendants
descendants
descendants
*might
live*

from DEUTERONOMY 30:19

As a visual artist I am particularly aware that what we take in through our eyes has the power to affect our whole being. The color scheme for this piece came from the beauty of the spectrum that is revealed through light.

Light of the world, shine into our hearts to reveal any darkness that might draw us away from you. Fill us with your perfect light so that we will be able to spread your goodness where evil reigns.

A LAMP
A BODY
EYE LETS
IF YOU ARE
SHINE INTO YOUR SOUL
FILLED WITH LIGHT
T AN EVIL EYE
WITH NO DARK CORNERS
HUTS OUT THE LIGHT THEN
AND PLUNGES YOU YOUR WHOLE LIFE
INTO DARKNESS. WILL BE RADIANT
MAKE SURE THAT AS THOUGH
THE LIGHT A FLOODLIGHT
IS SHINING ON YOU
YOU THINK YOU HAVE
S NOT REALLY
DARKNESS

IF YOU ARE
YOUR EYE IS
FILLED WITH LIGHT
A LAMP FOR YOUR BODY
WITH
A PURE EYE LETS SUNSHINE
NO DARK CORNERS
INTO YOUR SOUL
THEN
BUT AN EVIL EYE
YOUR WHOLE LIFE
SHUTS OUT THE LIGHT
WILL BE RADIANT
AND PLUNGES YOU INTO DARKNESS
AS THOUGH
MAKE SURE THAT THE LIGHT
A FLOODLIGHT
YOU THINK YOU HAVE
IS SHINING
IS NOT REALLY DARKNESS
ON YOU

from LUKE 11:34-36

I WILL GIVE THEM
AND PUT A NEW SPIRIT
WITHIN THEM
I WILL TAKE AWAY
THEIR HEARTS OF STONE
and give them
tender hearts
instead

The watercolor background
wash in this piece is punctuated
with a sprinkling of coarse salt.
The contrast symbolizes the
miracle of God to turn a person
180 degrees. It is difficult to
reproduce perfectly in printing,
but the last phrase is rendered
in gold leaf as a reminder
that tender hearts are precious
to God.

God of new beginnings, forgive
us for our lack of sensitivity to
those around us. Protect us
from those things that lead us
away from you. May our lives
bring joy to you.

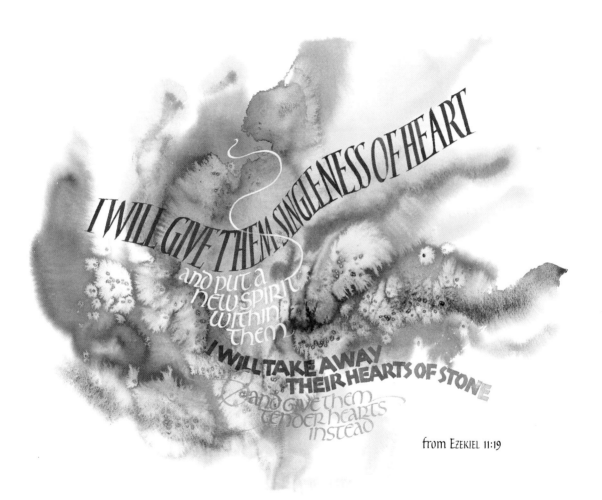

I WILL GIVE THEM SINGLENESS OF HEART and put a new spirit within them I WILL TAKE AWAY THEIR HEARTS OF STONE and give them tender hearts instead

from EZEKIEL 11:19

KEEP ON ASKING
and you will be given
what you ask for
KEEP ON LOOKING
and you will find
KEEP ON KNOCKING
and the door will be opened

Sometimes when we are in the middle of a big decision, we feel as if life is a big maze. This was the metaphor that came to me for arranging these words. Closed doors along the way can be discouraging, but my experience has been that if we persist in our search, God comes through with an open door in the end.

Guardian of our way, thank you that even though sometimes we are clueless, you have the best prepared for us. Teach us to be patient in the in-between times. Help us to do our part in the process.

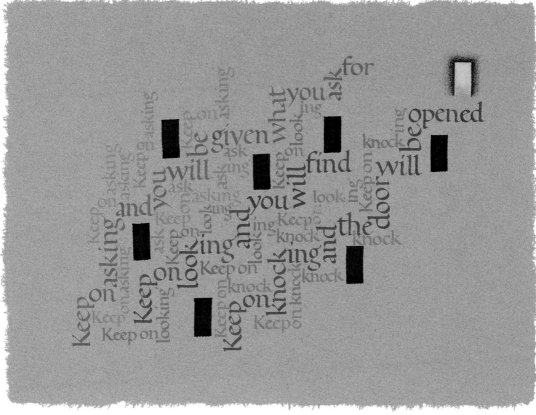

Keep on asking
Keep on asking
Keep on asking
and you will
be given
ask ask what you ask for
Keep on asking
look ing
you will find be opened
knock ing
Keep on
looking looking
and you will
knock ing
the door will
Keep on
look on knock
and knock
Keep on knock

from Matthew 7:7

YOU CAN ENTER
GOD'S KINGDOM
ONLY THROUGH
THE NARROW GATE

The highway to
hell is broad
and its gate is wide
for the many
who choose
the easy way
BUT
the gateway to life is small
and the road is narrow
and only a few ever find it

It is difficult for me to speak Jesus' strict message here in a culture where tolerance rules. Yet I felt a compulsion to include its warning in order to be completely faithful to the body of his teaching. I believe the language of visual art can sometimes communicate to deaf ears.

Lord Jesus, we acknowledge you to be the Way, the Truth, and the Life. Keep us from the distractions that can pull us away from your path that leads to heaven.

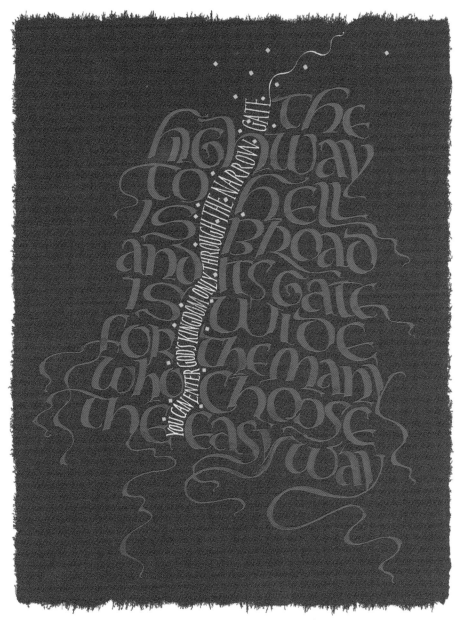

THE WAY TO HELL IS BROAD AND ITS GATE IS WIDE THE MANY CHOOSE THE EASY WAY FOR WHO

YOU CAN ENTER GOD'S KINGDOM ONLY THROUGH THE NARROW GATE

from MATTHEW 7:13

For Jesus' use of the pronoun *me*, I created an illuminated initial similar to those that medieval scribes used to honor God's name. The letters at the beginning and the ending originate from the same historic style but are interpreted differently from each other. They contrast our lack of fulfillment apart from Christ versus the abundant life that results in him. The spattering is added to portray the zest for life he wants us to experience.

Living Water, thank you for your generous invitation. Forgive us for trying to fill up with things that don't satisfy. We open ourselves up to you so that you may flow freely through us in all your goodness and power.

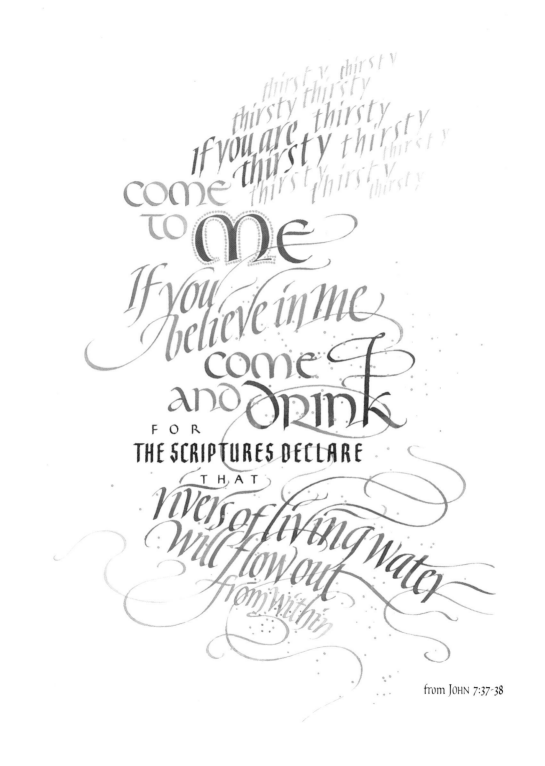

thirsty thirsty
thirsty thirsty
thirsty thirsty
If you are thirsty
thirsty thirsty
thirsty thirsty
thirsty thirsty
thirsty thirsty
thirsty

come
to me

If you
believe in me
come
and drink

FOR

THE SCRIPTURES DECLARE

THAT

rivers of living water
will flow out
from within

from JOHN 7:37-38

The lines in my own hand became the pattern I followed for writing out this message. Then I used the colors to have a double meaning. When we are bruised our skin often takes on different colors. Jesus was bruised for us so that we might receive the joy of resurrection hope. That joy is also portrayed by the various colors.

Lord Jesus, like Thomas, we have our doubts. But we reach out to you like Peter; we believe. Help our unbelief.

Thank you for the historical record of your life, and thank you that those of us who were not present for your triumph over death can look ahead to your triumphant return.

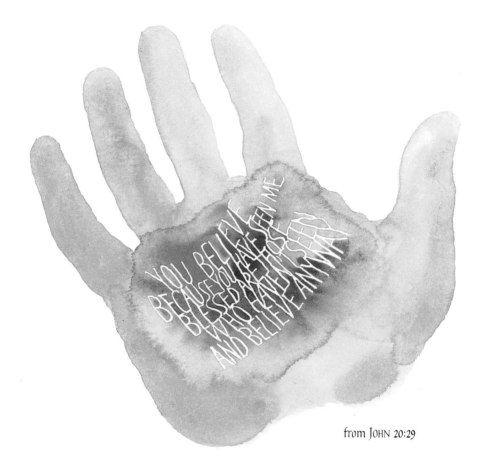

YOU BELIEVE BECAUSE YOU HAVE SEEN ME BLESSED ARE THOSE WHO HAVEN'T SEEN AND BELIEVE ANYWAY

from JOHN 20:29

Those who become Christians become new persons.
They are not the same anymore.
A new life has begun
for the old life is gone.

In these verses I likened a person's new faith to putting on a new coat identified by the cross of Christ. Since artists are by nature introspective and self-absorbed, the second verse challenges me to use my gift in ways that honor the Lord and serve others.

Lord and Savior, thank you for beginning a new life in us. Thank you for freeing us from dead-end pursuits and for giving us such noble purpose for our work.

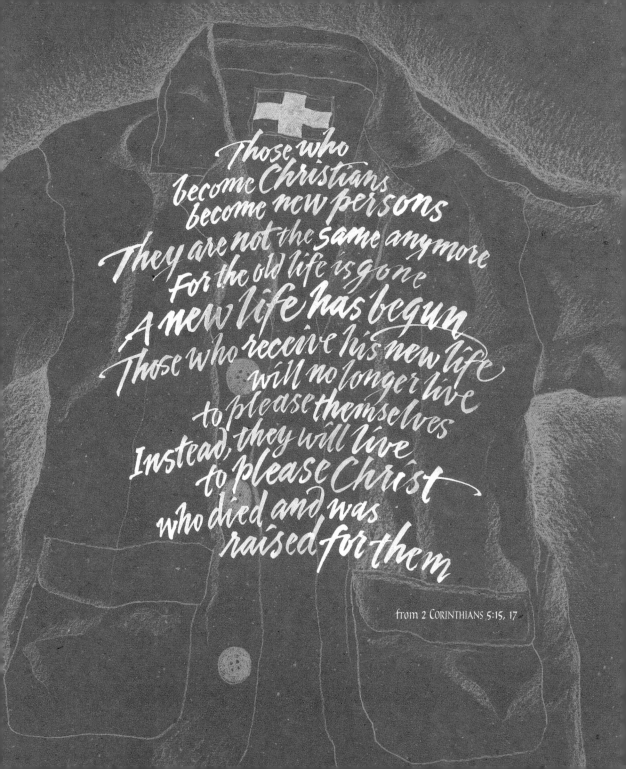

Those who
become Christians
become new persons
They are not the same anymore
For the old life is gone
A new life has begun
Those who receive his new life
will no longer live
to please themselves
Instead, they will live
to please Christ
who died and was
raised for them

from 2 CORINTHIANS 5:15, 17

God blesses those who realize their need for him

God blesses those who mourn

God blesses those who are gentle and lowly

God blesses those who are hungry and thirsty for justice

God blesses those who are merciful

God blesses those whose hearts are pure

God blesses those who work for peace

God blesses those who are persecuted because they live for God

I drew a parallel between the beatitudes of Jesus and the rainbow. Like the sunshine after the rain, we can look forward to an eclipse of our current struggles. Contrasting

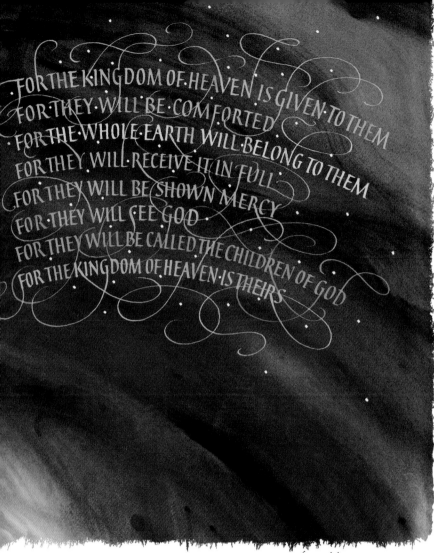

FOR THE KINGDOM OF HEAVEN IS GIVEN TO THEM
FOR THEY WILL BE COMFORTED
FOR THE WHOLE EARTH WILL BELONG TO THEM
FOR THEY WILL RECEIVE IT IN FULL
FOR THEY WILL BE SHOWN MERCY
FOR THEY WILL SEE GOD
FOR THEY WILL BE CALLED THE CHILDREN OF GOD
FOR THE KINGDOM OF HEAVEN IS THEIRS

from MATTHEW 5:3-10

lower case letters on the left with capitals on the right relates to a life of self-denial that yields rich rewards both now and in heaven.

God of hope, help us to learn the ways of your kingdom. Thank you for your blessings that extend from our present obedience to our final reward of sharing in the glory of heaven.

NOW
THERE IS
no condemnation
for those who belong to
CHRIST JESUS
FOR THE POWER OF
the Holy Spirit
HAS FREED YOU FROM
THE POWER OF SIN
THAT LEADS TO DEATH

The distinctive v-shape of this piece alludes to the tearing of the temple curtain when Jesus died, giving us access to a holy God. It also stands for the victory which is ours over evil strongholds. It is especially gratifying when an idea like this comes to mind and then works out so perfectly with the arrangement of the words.

God of grace, thank you that through the great sacrifice of Jesus on the cross, we are able to be free from sin's power. Help us to leave behind that from which you have freed us.

NOW THERE IS

NO CONDEMNATION

FOR THOSE WHO BELONG TO

CHRIST JESUS

FOR THE POWER OF

the life-giving Spirit

HAS FREED YOU

FROM THE POWER

OF SIN THAT

LEADS TO

DEATH

from ROMANS 8:1-2

The background for this piece is made in the form of a butterfly, a symbol of transformation, and of outstretched hands in worship and service. In the central part of the text, I made up the letterforms to express the uniqueness that God desires for those of us who follow him. I believe that of all artists I am the most free in my artmaking because God has delivered me from behavior that might otherwise enslave me.

Awesome God, thank you for not only saving us *from* destruction, but also saving us *for* the good life you want for us to have. May your perfect will be done in us today and always.

DEAR BROTHERS AND SISTERS
I PLEAD WITH YOU TO
GIVE YOUR BODIES TO GOD
LET THEM BE A LIVING AND HOLY SACRIFICE
THE KIND HE WILL ACCEPT
WHEN YOU THINK OF WHAT HE HAS DONE FOR YOU
IS THIS TOO MUCH TO ASK?
DON'T COPY THE BEHAVIOR AND
CUSTOMS OF THIS WORLD BUT

Let God transform you into a new person by changing the way you think

THEN YOU WILL KNOW
WHAT GOD WANTS YOU TO DO
AND YOU WILL KNOW
HOW GOOD AND PLEASING AND PERFECT
HIS WILL REALLY IS

from ROMANS 12:1-2

Then turning to his disciples
everyday life- whether you have enoug
consists of far more than food and clothin
harvest or put food in barns becaus
to him than any birds! Can all you
And if worry can't do little things lik
things? Look at the lilies and how th
Yet Solomon in all his glory was no
God cares so wonderfully for flowers th
surely care for you? You have s
what to eat or drink. Don't worry wheth
dominate the thoughts of most peop
HE WILL GIVE YOU ALL YO
MAKE THE KINGDOM OF GO

I chose the metaphor of a quilt,
made from various torn papers,
for God's covering and provision
for us. I appreciated the
response of a viewer where I

us said So I tell you, don't worry about
od to eat or clothes to wear. For life
ook at the ravens. They don't need to plant or
od feeds them. And you are more valuable
orries add a single moment to your life?
hat, what's the use of worrying over bigger
ow. They don't work or make their clothing,
essed as beautifully as they are. And if
'e here today and gone tomorrow, won't he
ttle faith! And don't worry about food—
od will provide it for you. These things
ut your Father already knows your needs
VEED FROM DAY TO DAY IF YOU
YOUR PRIMARY CONCERN

from LUKE 12:22-31

exhibited this piece: she aptly
remarked that if we could live
by these words our lives would
be complete.

Father in heaven, forgive us for
our lack of trust in you. Thank
you for the purpose you give to
our lives beyond food and
clothing. Help us to so focus on
your holy business that we are
able to put away our fears.

Store your treasures in heaven

where they will never
become moth eaten or rusty and
where they will be safe from thieves

and where thieves break in
and stea...

WHERE...
YOUR TREASURE...

I began this piece with plastic wrap crinkled and pressed on top of a background of colored inks dropped onto a wet surface. As this dried, a crystalline pattern formed as a backdrop for the text. Contrasting directions in the writing illustrate the tug and pull we experience, always choosing between perishable and eternal treasures.

Precious Lord, it's so easy for us to get caught up in accumulating more things. Thank you for setting our sights higher. Help us to invest in your kingdom, which has no end.

STORE YOUR TREASURE IN HEAVEN

Wherever your treasure is, there your heart and thoughts will also be

Don't store up treasures here on earth, where they can be eaten by moths and get rusty, and where thieves break in and steal

where they will never become moth-eaten or rusty, where they will be safe from thieves

from MATTHEW 6:19-21

You are truly
my disciples
if you keep
obeying my teachings

AND

YOU WILL KNOW

THE TRUTH

AND

the truth will set you free

you will indeed be free

Although there are wonderful guarantees in the Bible of our acceptance by God through faith in Jesus Christ, verses like this one warn us against careless-ness. To emphasize our need to practice our faith, I repeatedly illustrated the phrase, *Keep obeying my teachings.*

Lord of liberty, thank you for disciplines that lead to freedom. Through your perfect truth, set us free to be all that you desire for us.

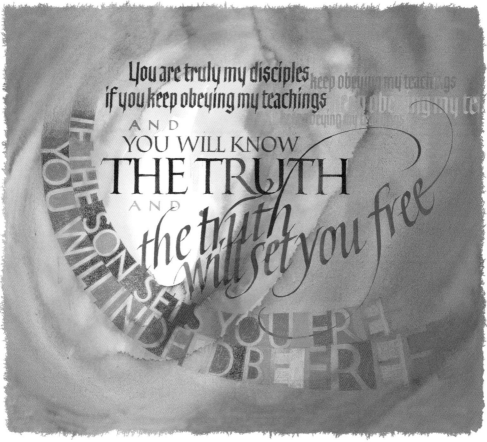

You are truly my disciples
if you keep obeying my teachings

AND

YOU WILL KNOW

THE TRUTH

AND

the truth will set you free

IF THE SON SETS
YOU WILL INDEED BE FREE

from JOHN 8:31-32, 36

YOUR BODY IS THE TEMPLE OF THE HOLY SPIRIT WHO LIVES IN YOU AND WAS GIVEN TO YOU BY GOD YOU DO NOT BELONG TO YOURSELF FOR GOD BOUGHT YOU WITH A HIGH PRICE SO YOU MUST HONOR GOD WITH YOUR BODY

It is fascinating to think of our body as a temple—a place where God chooses to reside. To try to picture such a concept is to celebrate what we cannot see. The white uncial letters date from as early as the third century, but I combined them with flourishes from the fifteenth century. This shows the advantage present-day artists have: to borrow and mix from the past.

Spirit of God, thank you for your willingness to dwell in us. Forgive us for our arrogance, for forgetting that all we have is from you. Help us to do the housecleaning that will make our lives a fitting place for you.

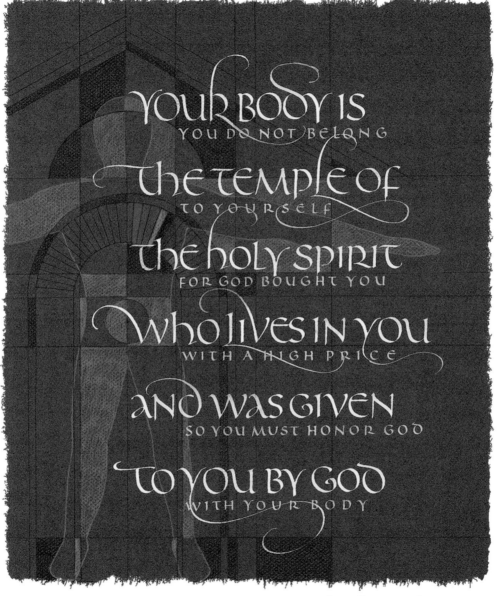

YOUR BODY IS
YOU DO NOT BELONG

THE TEMPLE OF
TO YOURSELF

THE HOLY SPIRIT
FOR GOD BOUGHT YOU

WHO LIVES IN YOU
WITH A HIGH PRICE

AND WAS GIVEN
SO YOU MUST HONOR GOD

TO YOU BY GOD
WITH YOUR BODY

from 1 CORINTHIANS 6:19-20

All The People of Israel
were CELEBRATING before
The LORD
with ALL their might
singing SONGS and
PLAYING all KINDS of
MUSICAL INSTRUMENTS
and David danced
BEfORE the LORD
with ALL His Might

This is the quintessential text
in the Bible for artists. It is a
picture of our deep passions
properly directed in praise of
our God. In our enthusiasm for
sports, this passage reminds us
to reserve our best energy for
God's purposes.

Most worthy Lord, we confess
that sometimes our apprecia-
tion of you has been half-
hearted. Give us a fresh vision
of your glory. Release the artist
in all of us to extravagantly
pour out our expressions of
praise.

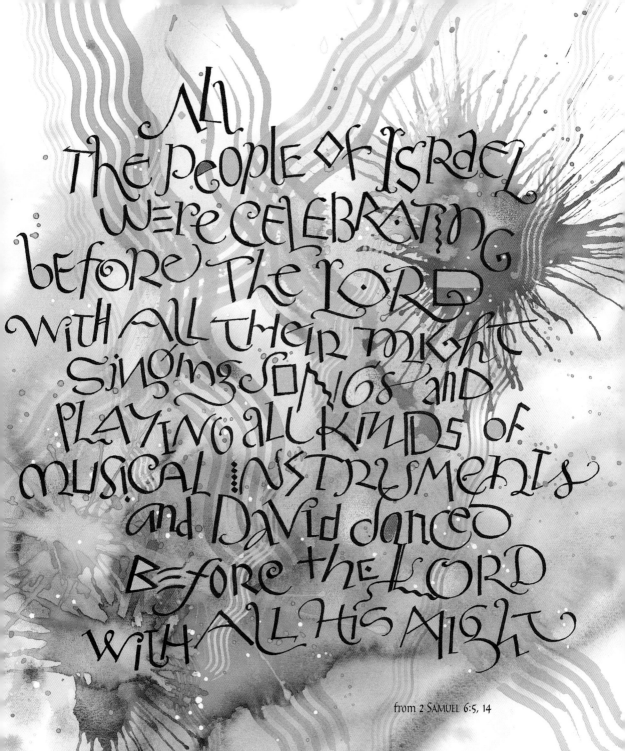

All
the people of Israel
were celebrating
before the Lord
with all their might
singing songs and
playing all kinds of
musical instruments
and David danced
before the Lord
with all his might

from 2 Samuel 6:5, 14

TRUE
Honorable
R I G H T
PURE
lovely
ADMIRABLE
Excellent
AND
worthy of praise

This verse has been my guide in choosing what words to write these past thirty-four years. Deciding how to portray each adjective really helped me to meditate on the nuances of their meanings. My son-in-law chose this text for his graduation present from me. How fulfilling it is for me to design such words for display in homes and public places!

Holy God, our thoughts fall so short of your glorious goodness. Renew our minds so that your beauty may permeate the world through us.

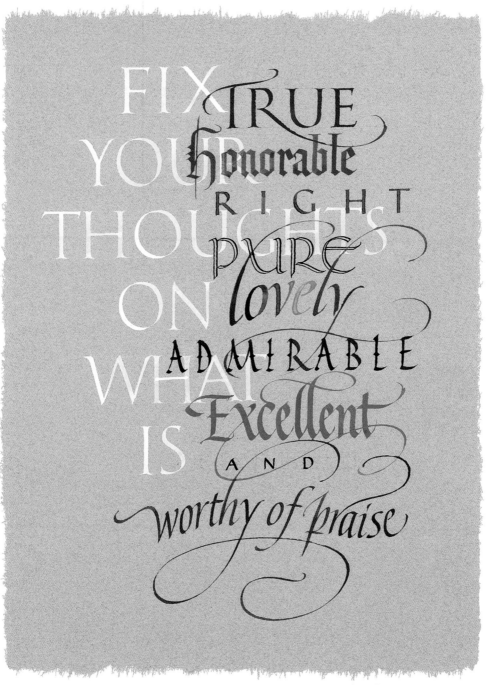

FIX YOUR THOUGHTS ON WHAT IS

TRUE
honorable
RIGHT
PURE
lovely
ADMIRABLE
Excellent
AND
worthy of praise

from PHILIPPIANS 4:8

I KNOW
THE PLANS
I HAVE FOR YOU

SAYS THE LORD

THEY ARE PLANS
FOR GOOD
AND NOT
FOR
DISASTER TO GIVE YOU
A FUTURE
and a hope

This has been the most requested of all the verses that I have written for people. The interlocking letters at the beginning suggest the intricacy of God's work behind the scenes. Some might think that I have ruined the design with the broken-up words of disaster. It's a visual reminder to stay close to the one who is able to keep us from destruction.

Sovereign Lord, we are grateful that you know all about us and that your intentions are for our good. Help us to stay tuned to how you are leading so that we don't miss out on your perfect plan for us.

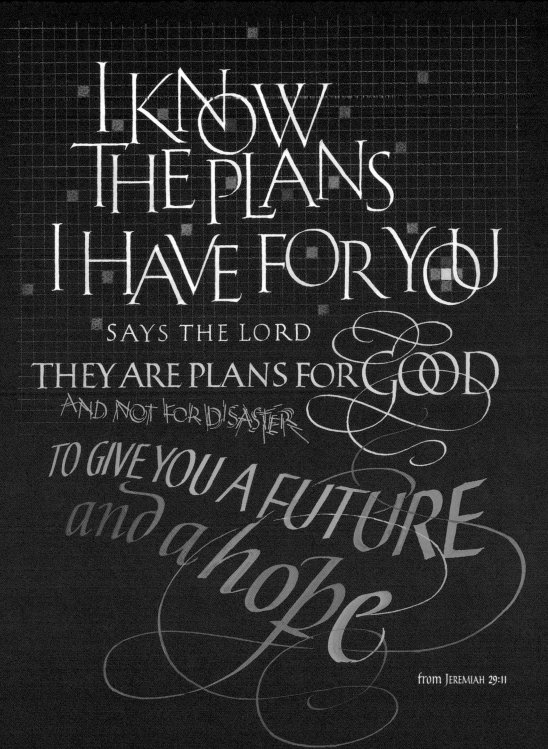

I KNOW THE PLANS I HAVE FOR YOU SAYS THE LORD THEY ARE PLANS FOR GOOD AND NOT FOR DISASTER TO GIVE YOU A FUTURE and a hope

from JEREMIAH 29:11

THOSE WHO WAIT ON THE LORD
WILL RENEW THEIR STRENGTH
They will fly high on wings like eagles
They will run and not grow weary
THEY WILL WALK AND NOT FAINT

Pen flourishes are an important element of Western calligraphy. They convey the flight of the soul, the glory of the skies, the freedom of space. When I first studied them, I thought it was necessary to do them very fast. Then I watched a more accomplished calligrapher move smoothly and *slowly* across the paper. It was like an eagle gliding, and I realized that I needed a peaceful spirit inside to produce such grace.

Spirit of God, help us to rest in the knowledge that you supply all the energy we need for the journey.

THOSE WHO WAIT ON THE LORD
WILL FIND NEW STRENGTH
They will fly high
on wings like eagles
They will run and not grow weary
They will run and not grow weary

THEY WILL WALK AND NOT FAINT

from ISAIAH 40:31

When you go through
deep waters
and great trouble

THE LORD
WHO CREATED YOU
SAYS Do not be afraid
for I have ransomed you
I have
called you
by name,
you are mine

I WILL BE WITH YOU

When you walk through
the fire of oppression

THE FLAMES WILL NOT CONSUME YOU

To begin this piece I painted a background in the various colors I associate with deep waters and fire. Then I wrote the largest words with a resist, a substance like rubber cement that flows more freely, followed by washes of black ink. When the paint dried, I rubbed off the resist, allowing the large words to come through in color. The final step was to write the hopeful parts of the verse on top in white.

Lord and Savior, how good it is to know that you are with us through the tough times. Give us the faith to trust you more.

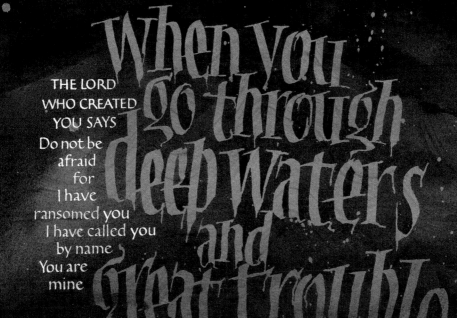

When you
go through
deep waters

THE LORD
WHO CREATED
YOU SAYS
Do not be
afraid
for
I have
ransomed you
I have called you
by name
You are
mine

and

great trouble

I WILL BE WITH YOU

When you
walk through
the fire of
Oppression

THE FLAMES WILL NOT CONSUME YOU

from ISAIAH 43:1-2

Bring ye all the tithes into the storehouse... and prove me now herewith, saith the Lord of hosts, if I will not open you the windows of heaven, and pour you out a blessing, that there shall not be room enough to receive it.

Generosity is a habit that should be developed from a young age. The meaning of generosity has been made real to me by observing my wife's pattern of cheerful giving. One summer, growing up on a farm, she grew popcorn and sold it to support a mission for the blind in India. For this piece, I wanted to capture the white of the paper to bring light into the picture—a favorite technique of many artists. The window shapes are skewed to suggest another dimension, one that we long to see and understand.

Gracious God, help us to give as freely as we have received.

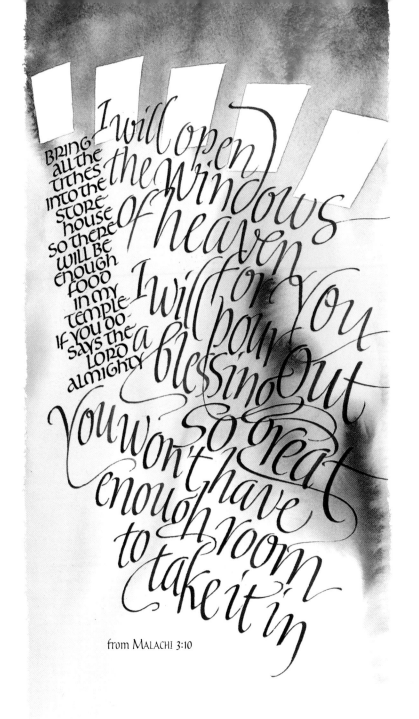

BRING all the tithes into the storehouse so there will be enough food in my temple. If you do, says the LORD almighty, I will open the windows of heaven for you. I will pour out a blessing so great you won't have enough room to take it in

from MALACHI 3:10

USE
EVERY PIECE
OF GOD'S ARMOR
TO RESIST THE ENEMY
IN THE TIME OF EVIL
SO THAT
AFTER THE BATTLE
YOU WILL STILL BE
STANDING
FIRM

One of my most straightforward designs comes from a sober battle text where embellishment doesn't fit. Of all the pieces of armor, the shield stood out as the most representative image of protection. All of the armor images in this passage are symbolic, so picturing them seemed to diminish their spiritual strength. The upright symmetry of the composition also contributes to a sense of alertness.

Almighty God, thank you for all that you have provided for our protection from Satan's treachery. Help us to use what you have given. Thank you for the ultimate victory that is ours in Jesus Christ.

USE
EVERY PIECE OF
GOD'S ARMOR
TO RESIST THE ENEMY
IN THE TIME OF EVIL
SO THAT
AFTER THE BATTLE
YOU WILL STILL BE
STANDING
FIRM

from EPHESIANS 6:13-17

Starting with a mid-tone paper enables me to create the illusion of depth by working with colors both darker and lighter than the background. In this case I brought out the contrast between the fractured black letters with the lighter words of praise riding on top.

Sovereign Lord, we confess that we don't understand why some things happen. Give us the grace to focus on the privilege of our relationship to you. Help us to remember that you are faithful and mighty to help us.

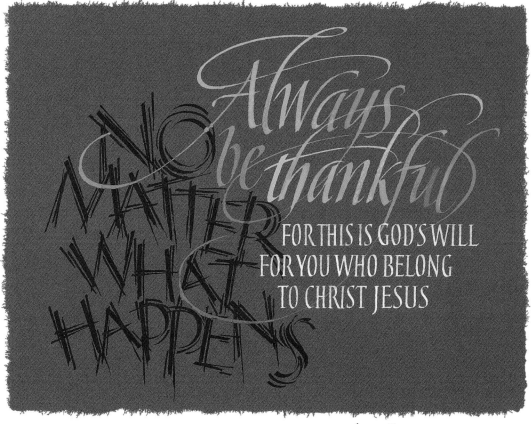

Always be thankful

NO MATTER WHAT HAPPENS

FOR THIS IS GOD'S WILL
FOR YOU WHO BELONG
TO CHRIST JESUS

from 1 Thessalonians 5:18

The creative tension between expression and legibility is always present in my work. It is especially evident here because the words speak of such upheaval. In order to preserve the message, I need to respect the Western custom of reading top to bottom and left to right. In spite of this limitation, I often allow the background to convey much of the emotion.

Lord God, help us to realize that our home here is temporary, that as magnificent as our universe is, it is flawed. You are our only hope of survival, and we trust you to transport us to our heavenly home.

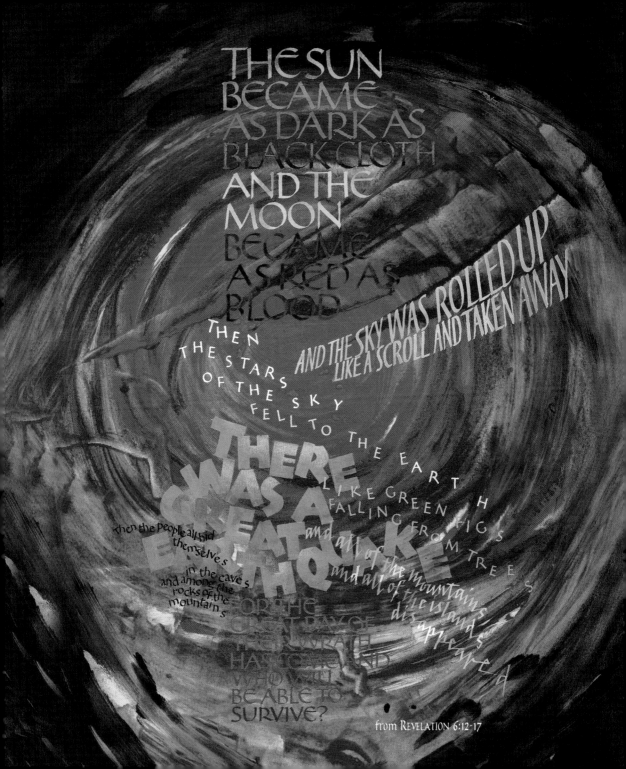

THE SUN BECAME AS DARK AS BLACK CLOTH AND THE MOON BECAME AS RED AS BLOOD AND THE SKY WAS ROLLED UP LIKE A SCROLL AND TAKEN AWAY THEN THE STARS OF THE SKY FELL TO THE EARTH LIKE GREEN FIGS FALLING FROM TREES and all of the mountains and all of the islands disappeared THERE WAS A GREAT EARTHQUAKE then the people all hid themselves in the caves and among the rocks of the mountains FOR THE GREAT DAY OF THEIR WRATH HAS COME AND WHO WILL BE ABLE TO SURVIVE?

from REVELATION 6:12-17

I am convinced that nothing can ever separate us from God's lo...

This is the passage to learn if you have a phobia because here we learn that Jesus has us covered on all fronts! I appreciated the vision of a funeral director in Minnesota who asked me to write out this text for the cover of their memorial leaflets. More than a sentimental picture, these words offer a powerful hope to us at the point of our greatest need.

Mighty Savior, thank you that no matter what giant we face, you are greater. Forgive us for worrying. Help us to trust you more.

I am
convinced
that DEATH CAN'T
and life can't
nothing the angels can't
can ever and the demons can't
our fears for today
separate OUR WORRIES ABOUT
us from TOMORROW
the love AND EVEN THE POWERS OF HELL
of God WHETHER WE ARE
HIGH ABOVE THE SKY OR
IN THE DEEPEST OCEAN
that is
revealed in NOTHING IN
ALL CREATION
Christ Jesus
our Lord

from ROMANS 8:38-39

LISTEN!
A farmer went out
to plant some seed.
As he scattered it
across his field
some seed fell on a footpat
and the birds came
and ate it

Anyone who plants a garden knows that from the time seeds are first planted until harvest, a lot of things can go wrong along the way. I've used various spacing, direction, and flourish to visually express the drama of Jesus' parable. When asked why I work so much with Scripture, I point to the fruit that I pray will result from my work.

ANYONE
WHO IS
WILLING
TO HEAR
SHOULD
LISTEN
AND
UNDERSTAND!

Still other seed
fell on fertile soil
and produced a crop
that was thirty, sixty,
and even a hundred times
as much as
had been planted

Other seed fell among thorns
that shot up and choked out
the tender blades
so that it produced no grain

her seed fell on shallow soil
with underlying rock
The plant sprang up quickly
but it soon wilted beneath the hot sun
because the roots had no nourishment
in the shallow soil and died

from MARK 4:3-9

Living Word, help us to receive
the blessings you want to give
us through your truth. Then
help us to spread your words
freely, looking forward to the
final harvest.

I was reminded by this verse that as we faithfully introduce people to Jesus, they will be attracted to him. To simplify a design, I often look for a way to make the letters become part of the illustration—in this case, connecting them to form a net. The various colors of fish are a picture of the wonderfully diverse body of those who follow Christ.

Lord and Master, thank you for the privilege of being in your family. Thank you for those who pointed us to you. Teach us how to live so that others will be attracted to you.

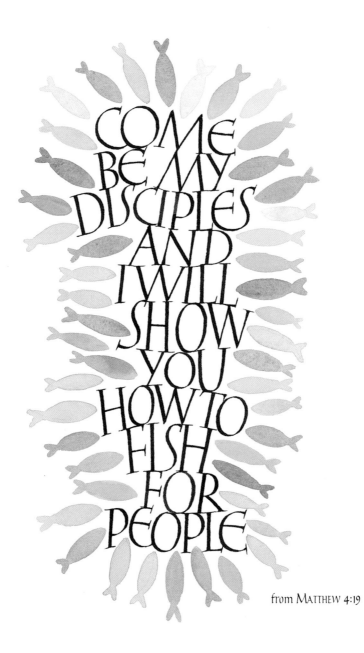

COME
BE MY
DISCIPLES
AND
I WILL
SHOW
YOU
HOW TO
FISH
FOR
PEOPLE

from MATTHEW 4:19

If it weren't for Peter's intriguing dream, the gospel would have stayed within Jewish borders. So I wanted to make a picture of God's vision for a multicultural church. Stylizing the various animals points to the principle of diversity and allows for broad application.

* * *

Father of all peoples, thank you for including us in your vision. Forgive us for being less inclusive than you are. Make us your instruments in reaching out to those you are calling from the four corners of the earth.

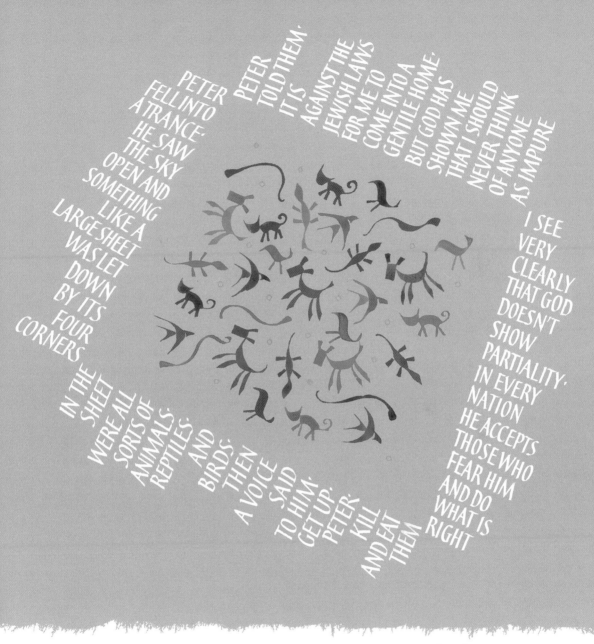

PETER TOLD THEM· IT IS AGAINST THE JEWISH LAWS FOR ME TO COME INTO A GENTILE HOME· BUT GOD HAS SHOWN ME THAT I SHOULD NEVER THINK OF ANYONE AS IMPURE

PETER FELL INTO A TRANCE· HE SAW THE SKY OPEN AND SOMETHING LIKE A LARGE SHEET WAS LET DOWN BY ITS FOUR CORNERS

IN THE SHEET WERE ALL SORTS OF ANIMALS· REPTILES· AND BIRDS· THEN A VOICE SAID TO HIM· GET UP· PETER KILL AND EAT THEM

I SEE VERY CLEARLY THAT GOD DOESN'T SHOW PARTIALITY· IN EVERY NATION HE ACCEPTS THOSE WHO FEAR HIM AND DO WHAT IS RIGHT

from ACTS 10:10-35

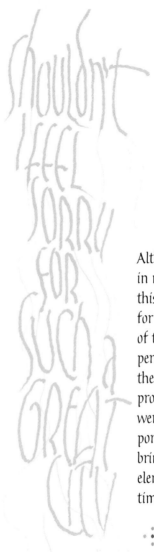

Shouldn't I feel sorry for such a great city

Although the Bible was written in much more agrarian times, this passage shows God's care for the urban condition. The use of torn paper and lack of perspective are metaphors for the complexity of the city's problems. Nineveh's buildings were certainly not as tall as portrayed here, but I like to bring in the contemporary element. It points to the timeless message of the Bible.

Merciful God, help us to care as much for the city as you do. Bless those who daily work to restore its brokenness. Show us how we can lend them support.

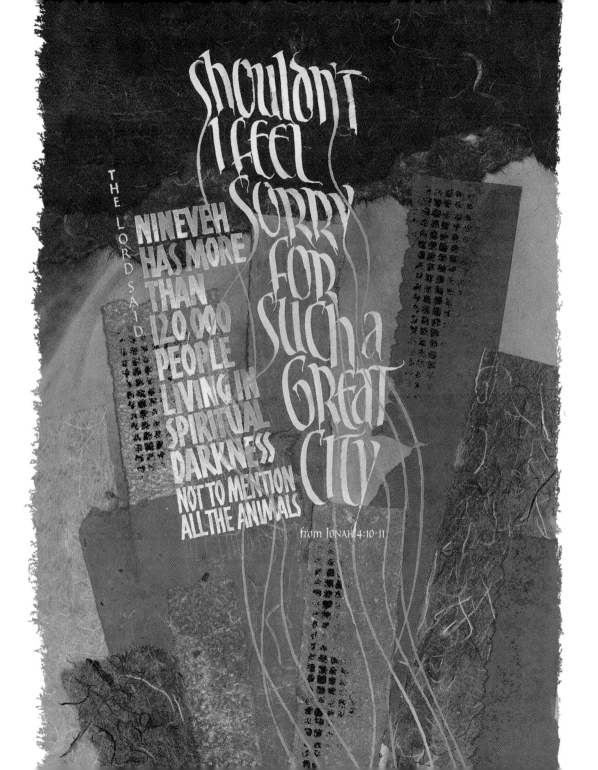

Shouldn't I feel sorry for such a great city

THE LORD SAID

NINEVEH HAS MORE THAN 120,000 PEOPLE LIVING IN SPIRITUAL DARKNESS NOT TO MENTION ALL THE ANIMALS

from JONAH 4:10-11

I HAVE BEEN GIVEN COMPLETE

THEREFORE G

AND make

baptizing them

Teach these new disciples

AND BE SURE OF THIS

I AM WITH YOU ALWAYS

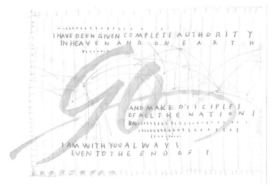

To illustrate Jesus' call to action, I chose to feature the simple verb *go* with singular movement and gigantic size. Inspired by the maps in flight magazines, I represented some of the major movements of

AUTHORITY IN HEAVEN AND ON EARTH

disciples of all the nations

in the name of the Father and the Son and the Holy Spirit

to obey all the commands I have given you

EVEN TO THE END OF THE AGE

from MATTHEW 28:18-20

missionaries obeying the great commission. The gold crosses celebrate the presence of the church in the largest population centers worldwide

Lord of all nations, thank you for the light of the gospel throughout the world. Help us, as we teach your commands, not to impose our own cultural mores. Thank you for the assurance that as we venture out, you go with us.

How beautiful on the mountains are the feet of those who bring good news of peace and salvation

I try to bring out the uniqueness of each text by the way I present it on paper. In this case I responded to the curious metaphor of beautiful feet. To celebrate those who go where the Lord's hope is needed, I painted these feet in a naive, colorful style.

Lord of compassion, thank you for your example. Thank you for those who carried your Good News to us. Move us in turn to reach out to those who need your joy in their lives.

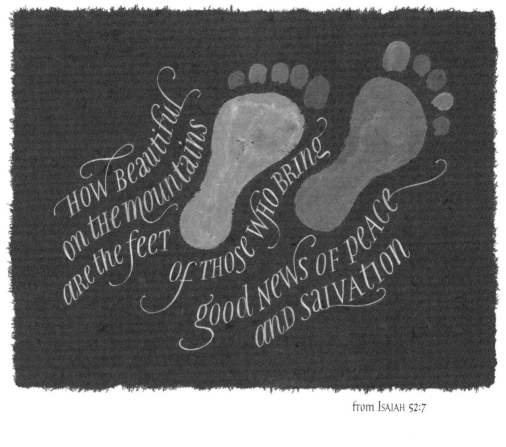

How beautiful on the mountains are the feet of those who bring good news of peace and salvation

from ISAIAH 52:7

TWO people
CAN ACCOMPLISH MORE than
TWICE as much as one;
If one person falls, the other
can reach out and help.
And on a COLD NIGHT,
two under the same blanket
can GAIN WARMTH
from each other.
A person standing alone
can be attacked and defeated,
BUT TWO CAN STAND back-to-back
and CONQUER.
Three are even BETTER,
for a TRIPLE-BRAIDED cord
is not easily broken.

The process of braiding three strands helped me to experience the truth of this proverb. Borrowing from a contemporary graphic design style, I used alternate words and phrases in capital and small letters, white and purple. This enabled me to heighten the emphasis in the text, much like the way we talk.

⋰⋱

Loving God, thank you for the relationships of family and friends who come alongside us. Most of all thank you that with you on our team, we are invincible.

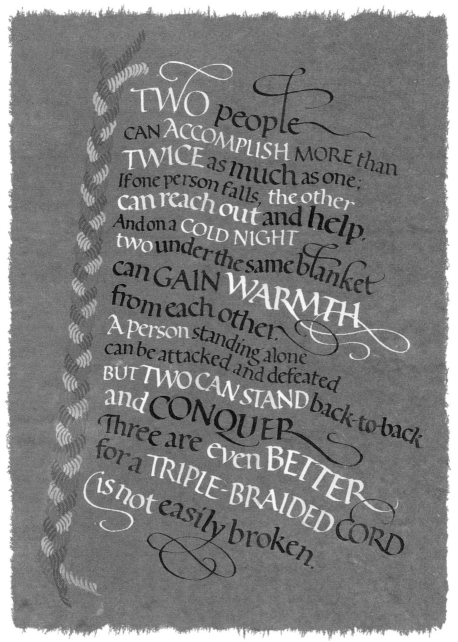

TWO people
CAN ACCOMPLISH MORE than
TWICE as much as one;
If one person falls, the other
can reach out and help.
And on a COLD NIGHT
two under the same blanket
can GAIN WARMTH
from each other.
A person standing alone
can be attacked and defeated
BUT TWO CAN STAND back-to-back
and CONQUER
Three are even BETTER
for a TRIPLE-BRAIDED CORD
is not easily broken.

from ECCLESIASTES 4:9-12

The winter
is past

and rain
the rain
is over
and
gone
gone
gon

THE
WINTER
IS and
PAST gone: are springing up
the rain
is over
and the flowers

and the time of singing birds
has come

rise, my beloved,
my fair one
and come away

Half of my design was solved
when I found this handmade
paper pressed with petals and
leaves. I did not want to
compete with the various colors
already in the background, but I
still wanted to express the
different parts of the text. So I
limited the writing to a neutral
dark green. One challenge I

The flowers are springing up and the time of singing birds has come Arise, my beloved, my fair one and come away

from SONG OF SONGS 2:11-13

continually face in my work is
to know when enough is enough!

Lord of the seasons, thank you
for your faithfulness as
expressed in each springtime.
Thank you for the poetry of
love. We love you because you
first loved us.

LOVE

IS PATIENT

and kind

Love is not jealous or boastful or proud or rude.

Love does not demand its own way.

Love is not irritable, and

it keeps no record of when it has been wronged.

It is never glad about injustice but

rejoices whenever the truth wins out.

Love never gives up,

never loses faith,

is always hopeful

and endures through

every circumstance

LOVE WILL LAST FOREVER

It was important to me not to communicate love as a sentimental feeling. Instead, my desire was to illustrate this passage as God's plan of action for his church as well as for both men and women. Clichés like the heart shape communicate very effectively, but the artist's challenge is to represent them in a fresh way—in this case, as if done by a draftsman.

God of love, thank you for your example of perfect love. Forgive us for giving up on others when you continue to love us.

LOVE

IS PATIENT

and kind

*Love is not jealous or boastful or proud or rude
Love does not demand its own way
Love is not irritable, and
it keeps no record of when it has been wronged
It is never glad about injustice but
rejoices whenever the truth wins out
Love never gives up
never loses faith
is always hopeful
and endures through
every circumstance*

LOVE WILL LAST FOREVER

from 1 CORINTHIANS 13:4-8

If two
of you
agree down
here on earth
concerning
anything
you ask
MY FATHER
IN HEAVEN
will
DO IT FOR YOU

The joy of fellowship with other believers is symbolized with letters that interlock with each other in different colors. The joy of the Lord's presence with us is exhibited through translucent layers of fingers one upon the other, producing a third color where they overlap.

Lord Jesus, thank you for your faithful answers to our prayers in the past. Increase our desire to meet together so that we may experience more of you and the mystery of your work accomplished through us.

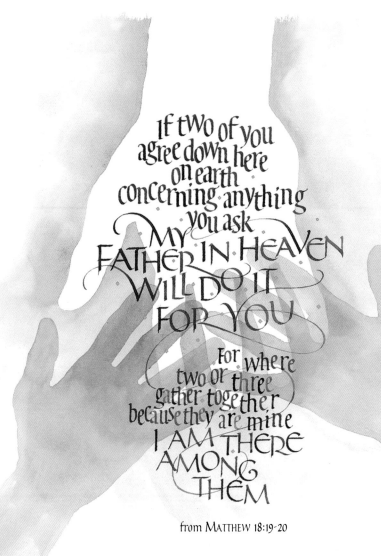

If two of you
agree down here
on earth
concerning anything
you ask
My
FATHER IN HEAVEN
WILL DO IT
FOR YOU

For where
two or three
gather together
because they are mine
I AM THERE
AMONG
THEM

from MATTHEW 18:19-20

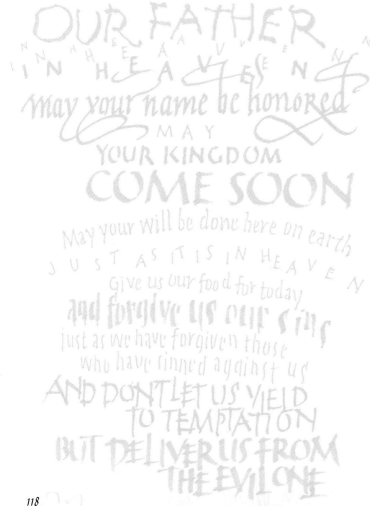

OUR FATHER
IN HEAVEN
May your name be honored
MAY
YOUR KINGDOM
COME SOON
May your will be done here on earth
JUST AS IT IS IN HEAVEN
Give us our food for today
and forgive us our sins
Just as we have forgiven those
who have sinned against us
AND DON'T LET US YIELD
TO TEMPTATION
BUT DELIVER US FROM
THE EVIL ONE

Jesus' model prayer begins with our addressing God as his children and is the reason for my frail letters for the first line. The eclectic arrangement of phrases points out just how much is packed into his words. It is also meant to jolt us from the complacency of familiarity—to revisit the words as if for the first time.

Our Father, we take this time to give you all the honor that is due you. Thank you that as we struggle to do your will here on earth, we also can look forward to a perfect place with you forever.

OUR FATHER

IN HEAVEN

May Your Name Be Honored

MAY

YOUR KINGDOM

COME SOON

May your will be done here on earth

JUST AS IT IS IN HEAVEN

Give us our food for today

and forgive us our sins

just as we have forgiven those
who have sinned against us

and don't let us yield to temptation

but deliver us from the evil one

from MATTHEW 6:9-13

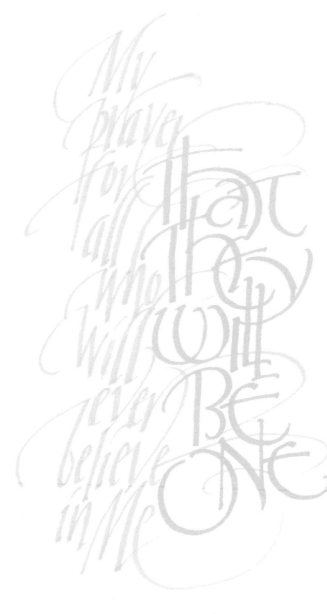

My prayer for all who will ever believe in Me that they will be one

One of my greatest longings is for my work to be an instrument of unity in the church. I have learned that as long as I stick with the biblical text, my artwork finds acceptance with nearly all types of Christians. As hinted inside the circle, this includes people of all nationalities, personalities, and abilities.

Lord of all, thank you for giving us the ideal of life lived in harmony with each other. Help us to seek unity under your allegiance so that others will be attracted to your family.

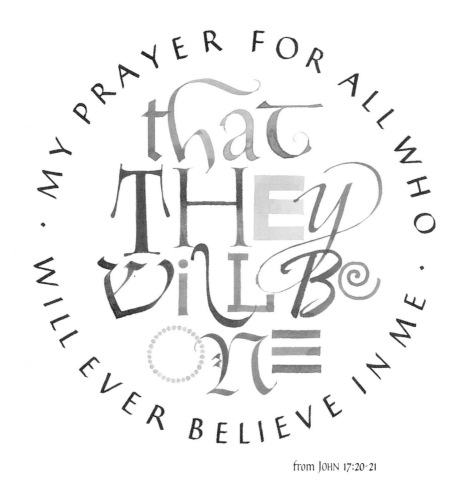

MY PRAYER FOR ALL WHO WILL EVER BELIEVE IN ME

that THEY will Be ONE

from JOHN 17:20-21

ALL THE BELIEVERS WERE OF ONE HEART AND MIND AND THEY SHARED EVERYTHING THEY HAD

The torn paper represents the imperfect state of our inter-action with each other in the body of Christ. But in the process of collage, the fibers of different papers are fused together as one fabric. This recalls for us the glue of the Holy Spirit who binds us together as we yield to his power.

Spirit of God, forgive us for our indifference to the needs of our neighbors. Only by your transforming power can we achieve the harmony you desire among us. Thank you for the joy that comes from breaking down the barriers.

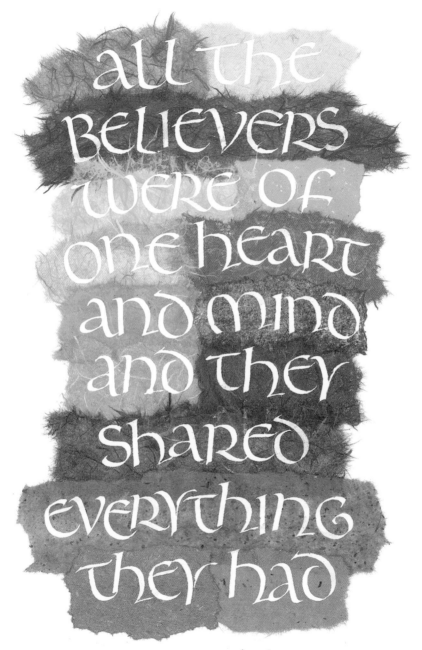

all the
BELIEVERS
were of
one heart
and mind
and they
shared
everything
they had

from Acts 4:32

Do not exploit
the foreigners
who live in your land
they must be treated
like everyone else
and you must love them
as you love yourself
remember that
you were once foreigners
in the land of Egypt

This passage is an example of the Bible's up-to-date wisdom. In so many countries today we find displaced peoples all around us. Since the age-old struggle in the Holy Land has been between Jew and Arab, I chose this style which imitates Arabic writing, unique for its westward slope.

Lord of all nations, forgive us for our lack of care for those who are strangers among us. Help us to treat them as we would like to be treated. And we pray for the peace of Jerusalem.

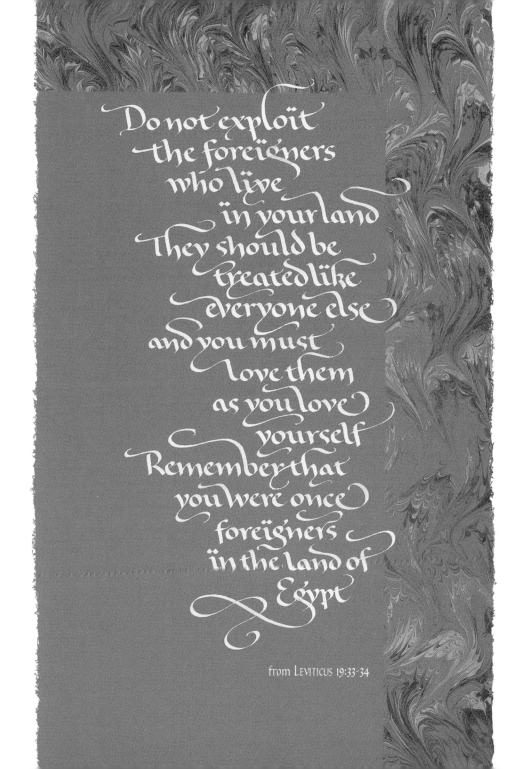

Do not exploit
the foreigners
who live
 in your land
They should be
 treated like
 everyone else
and you must
 love them
as you love
 yourself
Remember that
you were once
foreigners
in the land of
Egypt

from LEVITICUS 19:33-34

One summer when my wife and I joined a missions trip, we experienced the ritual of voluntary foot-washing. One high school student who was least friendly with me during the two weeks chose to wash my feet. It reminded me that actions speak louder than words. By writing Jesus' words in roman capital letters, I chose the most difficult—but also the most noble—rendition of our alphabet.

Lord and Teacher, thank you for your amazing example of love and humility. How can we do any less for our brothers and sisters? We offer ourselves to your service because you are worthy.

SINCE
I THE LORD
AND TEACHER
HAVE WASHED
YOUR FEET
YOU OUGHT TO
WASH EACH
OTHER'S FEET

from JOHN 13:14

A spoon, a pitcher, a chair, a shirt, leaves, and a key . . . they're all collaged from torn papers as simple gifts, simply given. When I chose the earthy background paper I was thinking of the expression "to get one's hands dirty." The interlinear writing is a way to say that two thoughts are true at the same time.

· · · ·
· · · ·
· · · ·

Merciful Lord, may we open our hearts and our hands to the needs of those around us, even this day. Forgive us for closing our eyes to those who need our help—for thinking little of those you call brother or sister.

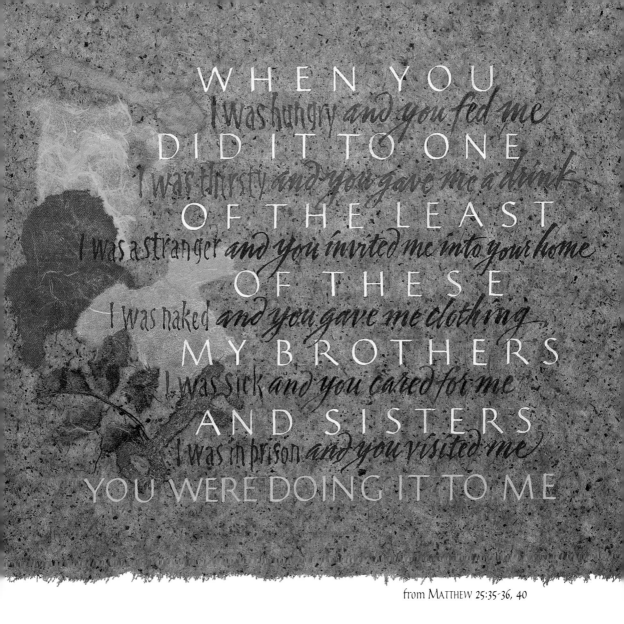

WHEN YOU
I was hungry and you fed me
DID IT TO ONE
I was thirsty and you gave me a drink
OF THE LEAST
I was a stranger and you invited me into your home
OF THESE
I was naked and you gave me clothing
MY BROTHERS
I was sick and you cared for me
AND SISTERS
I was in prison and you visited me
YOU WERE DOING IT TO ME

from MATTHEW 25:35-36, 40

I admire the work of two of our children in a troubled part of St. Louis to rebuild both houses and people there. By mobilizing volunteers, they are giving more affluent people of faith an opportunity to obey the word of God to Amos. As visualized by the two contrasting parts of the text, oppression is giving way to a joyful freedom.

Holy Father, we confess our complacency toward the injustice all around us. Empower by your Spirit those who work for just causes. Move us to action in our own sphere of influence.

I HATE ALL YOUR
SHOW AND PRETENSE
THE HYPOCRISY OF YOUR
RELIGIOUS FESTIVALS
AND SOLEMN ASSEMBLIES
AWAY WITH YOUR
HYMNS OF PRAISE
THEY ARE ONLY
NOISE TO MY EARS

I want to see
a mighty flood of justice
a river of righteous living
that will never run dry

from AMOS 5:21, 23-24

THIS IS WHAT THE LORD REQUIRES

to do what is right

AND TO WALK HUMBLY WITH YOUR GOD

My goal was to capture visually the meaning of each of the three parts of this verse. The disciplined gothic style of the second line emphasizes that God's truth doesn't change. The expression "to cut someone some slack" came to mind when I was writing the third line in a more flexible hand. My favorite are the last two lines, where I repeated the text as a reminder that we never walk alone when we choose his path.

Lord God, help us to recognize our place in the universe and to be faithful in what we can do. Forgive us for not taking seriously your perfect ways.

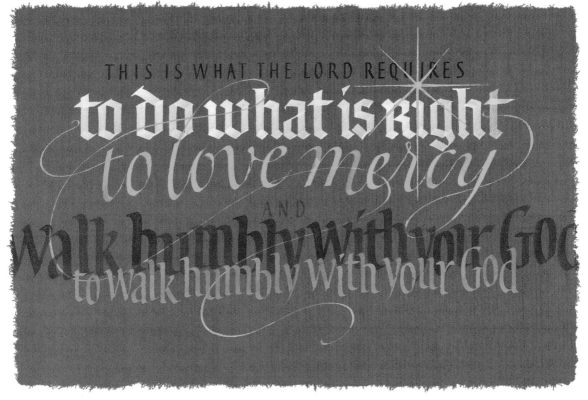

THIS IS WHAT THE LORD REQUIRES

to do what is right
to love mercy
AND
to walk humbly with your God

from MICAH 6:8

JUST

INSTEAD

Be kind to each other tender hearted still forgiving angry one another

AS GOD through CHRIST has FORGIVEN YOU

One of my favorite Pennsylvania Dutch expressions is, "Never go to sleep without a good-night kiss." Rooted in this Scripture, that piece of advice has helped my wife and me enjoy more peaceful nights together. The white letters on the right are made the largest because Christ's forgiveness puts our petty disagreements into proper perspective.

God of grace, thank you for forgiving the wrong things in our lives. Help us control our own anger and learn to accept the forgiveness of others.

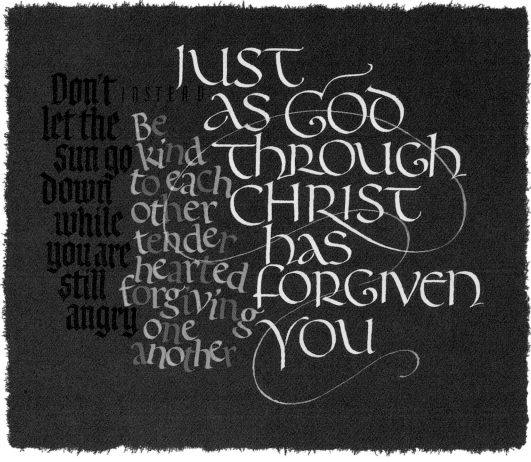

Don't INSTEAD JUST
let the Be AS GOD
sun go kind THROUGH
down to each CHRIST
while other has
you are tender FORGIVEN
still hearted YOU
angry forgiving
one
another

from EPHESIANS 4:26, 32

Here I enjoyed making a picture of the ability of love to conquer a formidable foe. I began with the background words in graffiti style, which angry people often paint. Then I completely surrounded this "enemy" with the delicate expression of love prevailing.

• • •
• • •
• •

Lord of love, thank you for the example of Jesus and others who paved the path of love before us. Help us to get beyond our own hatred to practice your command so that we can spread peace.

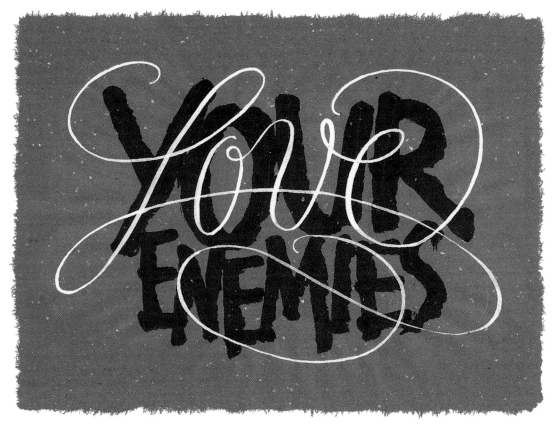

from LUKE 6:35

I borrowed from the rich Egyptian hieroglyphic tradition to create these letters and symbols for Joseph's story. The white plume represents Joseph's rise to power, the row of grain bundles are his brothers, the omniscient eye and the snake portray the struggle between good and evil. This is a wonderful example from ancient history that God is in the process of restoring what is broken—even today.

· · ·
· · · ·
· · ·

Redeemer Lord, thank you for your guiding hand upon our lives as we trust in you to lead us. Please open our hearts to the work of reconciliation you desire to do in broken relationships.

I AM JOSEPH YOUR BROTHER WHOM YOU SOLD INTO EGYPT
BUT DON'T BE ANGRY WITH YOURSELVES THAT YOU DID THIS TO ME
FOR GOD SENT ME HERE AHEAD OF YOU TO PRESERVE YOUR LIVES
AS FAR AS I AM CONCERNED GOD TURNED INTO GOOD
WHAT YOU MEANT FOR EVIL

from GENESIS 45:4-5; 50:20

Hardly is there a stronger contrast in the Bible than Jesus' words of forgiveness to those who were about to kill him! To illustrate this, I first wrote the second half of the text in multiple directions, creating a backdrop of confusion. Then I added Jesus' amazing declaration formally arranged in white roman letters.

· · · ·
· · · ·

Holy Father, forgive us, too, for not realizing the implications of our wrongdoing. And give us the grace to forgive those who have wronged us. Thank you for submitting to the cross so that we might have a way of escape from the doom we deserve.

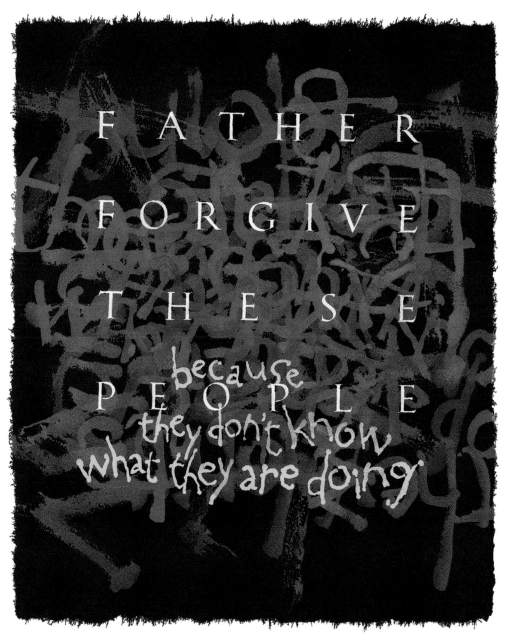

FATHER

FORGIVE

THESE

because

PEOPLE

they don't know

what they are doing

from LUKE 23:34

Whatever you do or say

Let it be as a representative of

THE LORD JESUS

It seems to be human nature to rally around a flag, a brand, a logo—some visual symbol of our identity and a sense of belonging. In designing a Christian banner I started with the cross, the means of our rescue from darkness. The encouraging words of this verse wave by the wind of God's spirit to complete the image.

⁘

Lord Jesus, you alone are worthy of our allegiance. Help us to more perfectly represent you in our work. Keep our eyes on you so that we won't be disillusioned when leaders fail us.

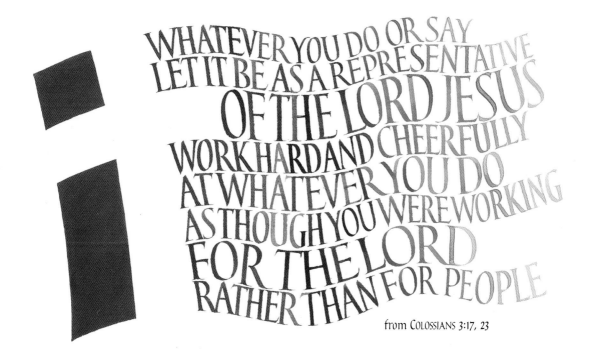

WHATEVER YOU DO OR SAY
LET IT BE AS A REPRESENTATIVE
OF THE LORD JESUS
WORK HARD AND CHEERFULLY
AT WHATEVER YOU DO
AS THOUGH YOU WERE WORKING
FOR THE LORD
RATHER THAN FOR PEOPLE

from COLOSSIANS 3:17, 23

Recently I joined with friends who have banded together to form an outreach in the arts to high school students. I personally have benefited from some great mentors, and we all feel the responsibility to pass on what we have learned. I borrowed from some of the traditional illumination used for testimonials to frame this, the ultimate certificate of award.

· · · · ·

Divine Master, forgive us for work poorly done, for laziness, for wasting our resources. Help us to do work that is pleasing to you. Bless our sincerest efforts for the glory of your name.

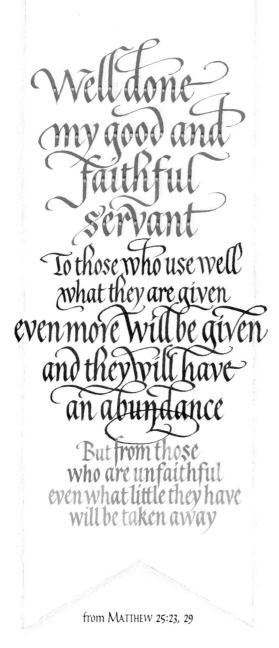

Well done
my good and
faithful
servant

To those who use well
what they are given
even more will be given
and they will have
an abundance

But from those
who are unfaithful
even what little they have
will be taken away

from MATTHEW 25:23, 29

Another symbol of the early church, the fish, was chosen because in Greek the word forms an acrostic for Jesus Christ, God's Son, Savior. Alluding to the mosaic art of the early Christians, I made up a chunky letter style. Then I added the path of movement through water to echo the text's energy.

Faithful Lord, thank you for the noble calling to serve you. We depend on you for the energy to keep going, especially through deep waters. Remembering your faithfulness in the past, we look forward to what you will do through us in the future.

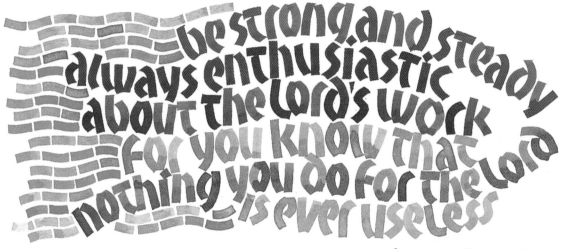

be strong and steady
always enthusiastic
about the Lord's work
for you know that
nothing you do for the Lord
is ever useless

FROM 1 CORINTHIANS 15:58

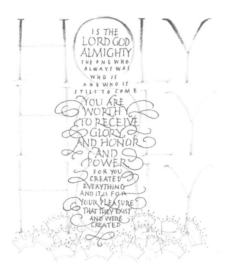

One of the shades of meaning in the word *holy* is to be totally separate or other. The sheer size of this word repeated three times, together with the smoky background, were my ways to convey the mystery and magnitude of God's nature. The crowns are appropriately placed at the lowest point of the composition.

Lord God Almighty, thank you for our privileged part in your grand scheme. For your perfect goodness we give you praise. Help us to fulfill your good purpose in our lives. Thank you for our future hope of being in your presence forever and ever!

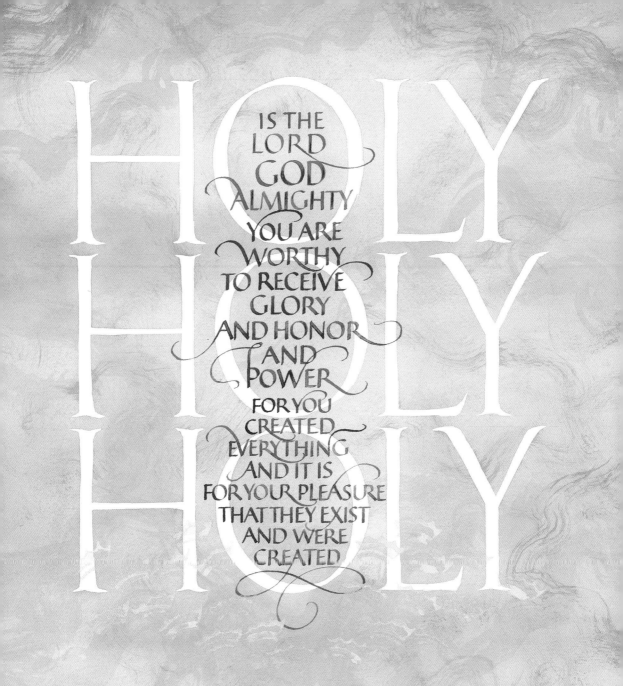

HOLY
HOLY
HOLY

IS THE
LORD
GOD
ALMIGHTY
YOU ARE
WORTHY
TO RECEIVE
GLORY
AND HONOR
AND
POWER
FOR YOU
CREATED
EVERYTHING
AND IT IS
FOR YOUR PLEASURE
THAT THEY EXIST
AND WERE
CREATED

from REVELATION 4:8, 11

INDEX OF SCRIPTURE

Other works by Timothy R. Botts

DOORPOSTS
His first book with
selections from Genesis
to Revelation

MESSIAH
The entire text of Handel's
Messiah interpreted in
expressive calligraphy

PROVERBS
Seventy-five proverbs
with contemporary
illuminated initials

BEST-LOVED BIBLE VERSES
A portfolio of twelve
ready-to-frame prints
of his most frequently
requested verses

PSALMS
The complete text of this
Bible book with more than
sixty full-page calligraphic
illustrations

THE HOLY BIBLE
Botts Illustrated Edition
Contains the illustrations in
this book, plus 285 others,
printed in full color